ROTHERHAM LIBRARY & INFORMATION SERVICES

This book must be returned by the date specified at the time of issue
as the DATE DUE FOR RETURN.
The loan may be extended (personally, by post or telephone) for a
further period if the book is not required by another reader, by quoting
the above number / author / title.

LIS7a

Please return to:
Patients' Library Level D
The Rotherham NHS Foundation
Trust Moorgate Road S60 2UD
(Tel: 01709 427139)

For Ludwig, Hettie and the late Beattie, a truly great bull terrier.

ACKNOWLEDGEMENTS

We are grateful to the numerous friends and acquaintances who provided information and suggested avenues of enquiry, in particular: Maia Adams, Janine Button, Basil Comely, Jilly Cooper, Jillian Edelstein, Daisy Garnett, Margaret Halton, Oriel Harwood, Jessica Hayns, Gavin Houghton, Nigel Jenkinson, David Kappo, Lucinda Lambton, Ruth Marshall-Johnson, Robin Muir, Lawrence and Anthea Mynott, Vanessa Nicolson, Toby Rose, Paul Simpson, Philippa Stockley, Marketa Uhlirova, Ann Verney, Angus Watt, Shona Watt, Tristan Webber, Jo Weinberg and Harriet Wilson. The London Library, Kennel Club and Dogs Trust too have been invaluable and a special 'thank you' goes to Katy Hart and Fiona Healey-Hutchinson at Battersea Dogs Home, the sterling staff of the Condé Nast Library in London, and to Cathie Arrington. Last, but not least, thank you to Mark and Nat at Sort Of Books, and to Ray Holland. And welcome to the wonderful world of dogs.

Published in 2005 by SORT OF BOOKS, PO Box 18678, London NW3 2FL
www.sortof.co.uk

Distributed by the Penguin Group in all territories excluding the United States and Canada:
Penguin Books, 80 Strand, London WC2R 0RL

Typeset in Today to a design by Peter Dyer
Printed in Italy by Lego
160pp

A catalogue record for this book is available from the British Library.
ISBN 0–954-2217-5-3

MEN & DOGS

JUDITH WATT & PETER DYER

Lieutenant Colonel George Custer with his scout team and hunting dogs, c.1870

George Armstrong Custer (1839–76) is seen here with members of the Seventh Cavalry in Montana, where they were guarding the building crews constructing the Northern Pacific railroad. He always travelled with his pack of about forty dogs, greyhounds and what were called 'stag hounds', similar in build to the Scottish deerhound, which he acquired in Texas; one of each breed is with Custer in the picture. The Native American standing closest to the tent door is thought to be Curly, the only survivor of General Custer's army who fought the allied Sioux and Cheyenne under the command of Sitting Bull at the Battle of the Little Big Horn on June 26, 1876. What happened to Custer's dogs immediately after the battle is unclear, but it was reported that they later found a home with the Mayor of Dodge City.

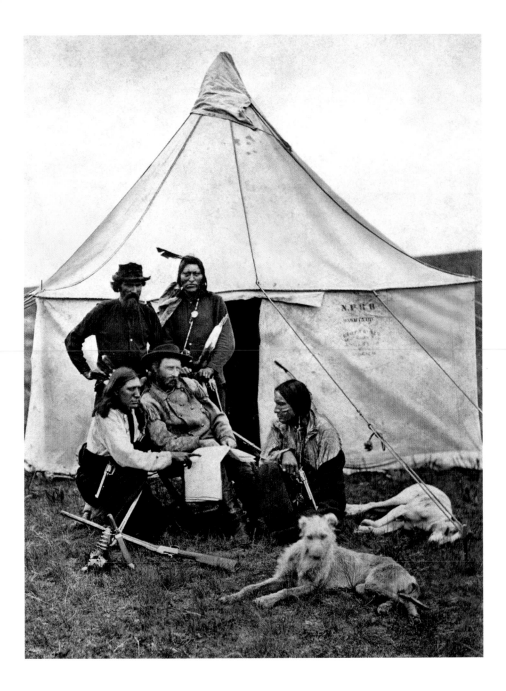

Alfred Hitchcock with Sarah, a West Highland white terrier, 1974

Sir Alfred Hitchcock (1899–1980), the director of such cult films as *Dial M for Murder* and *Psycho*, always kept dogs and, as an English émigré in Los Angeles in 1939, used them to demonstrate his Britishness, along with imported bacon, Dover sole and chintz loose covers. The Hitchcocks arrived in Hollywood with Edward IX the spaniel and Mr Jenkins the Sealyham, a particularly popular breed in the terrier-loving 1930s. Two new Sealyhams, Geoffrey and Stanley, followed, and appeared with him in *The Birds* (1963). Hitchcock may have terrified actors and audiences, but dogs loved him. 'My poodle Petunia adored him,' said Anne Baxter, who remembers Hitchcock sitting quietly on the sofa, stroking the dog after dinner. He knew that no one, least of all Petunia, would answer back.

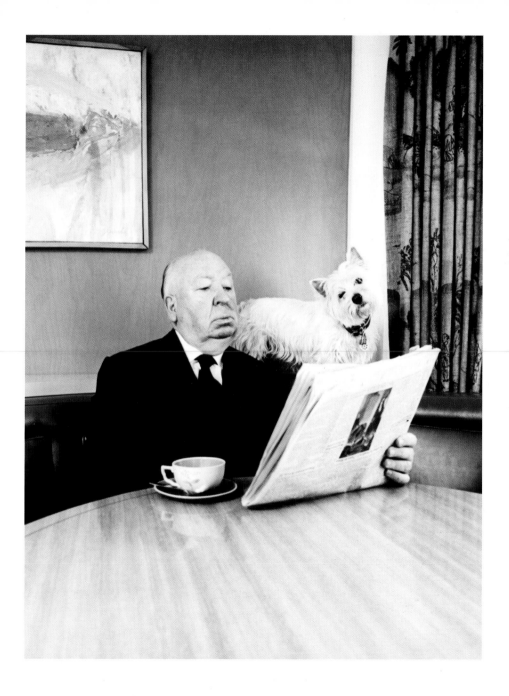

Humphrey Bogart and **Cappy**, early 1940s

Humphrey Bogart (1899–1957) was married to his third wife, Mayo Methot, and living in West Hollywood when this photograph of him resting his head on Cappy the Newfoundland was taken. He and Methot were dubbed the 'Battling Bogarts': drunken fights and shouting matches marked what was a largely unhappy marriage. The couple kept four dogs, numerous cats and cage birds at their home and, when they separated, Bogart took the dogs. After his marriage to Lauren Bacall in 1945, the couple acquired two boxers – Harvey and Babe – who with their pup George accompanied the Bogarts to the super-smart LA suburb of Holmby Hills. There, the boxers so disturbed the neighbours with their barking that a group of them lodged a complaint with the city council, and suggested the dogs have their vocal cords removed. 'What son of a bitch doesn't like dogs?' raged Bogie. 'What kind of monster is he? He ought to be glad he can hear the wonderful sound of dogs barking.'

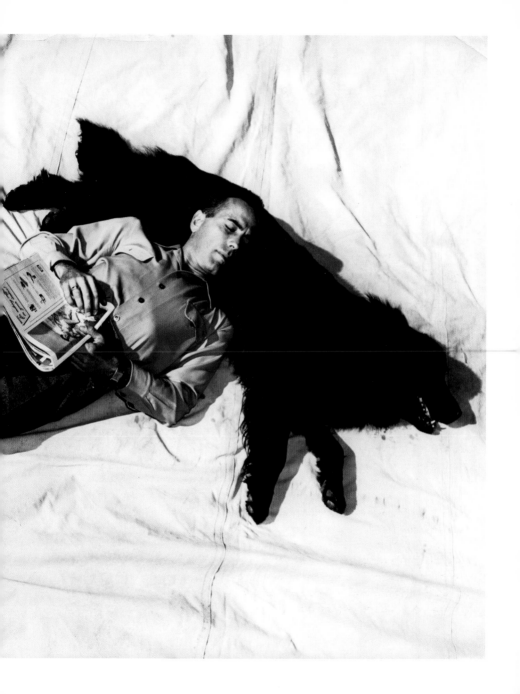

England World Cup team with Winston, their mascot, 1970

England had won the World Cup in 1966 and were favourites to do so again, four years later. The squad travelled to Mexico with their English bulldog mascot, Winston, but their luck ran out in the semi-final against Germany. Seen here, from left to right, are: Francis Lee, Bobby Charlton, Alan Ball, Norman Hunter, Ian Storey-Moore and Colin Bell. Dogs, oddly enough, played quite a role with England and the World Cup in this era. The trophy that they won in 1966 was stolen, and then famously discovered in a hedge by a dog named Pickles.

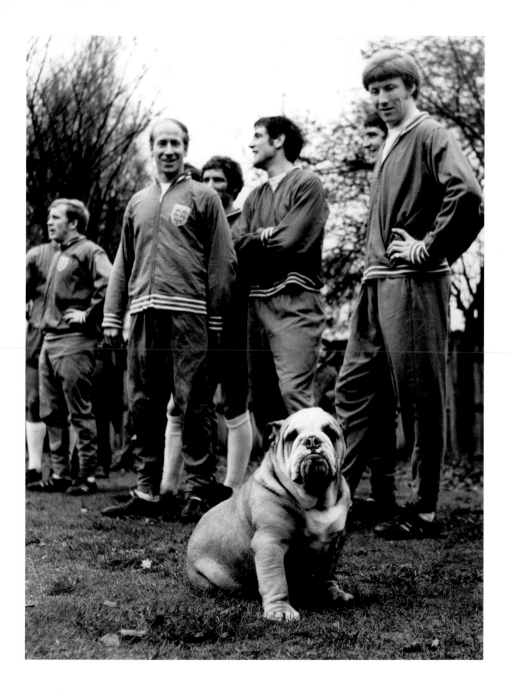

Paul Newman and **Joanne Woodward** with a small dog, 1958

Paul Newman (born 1925) and Joanne Woodward (born 1930) were photographed here, soon after their marriage in 1958, with an unidenti-fied little dog, obviously a treasured pet. Woodward, an intelligent and gifted actress, had a love of horses and dogs and the previous year the couple had given their friends Gore Vidal and Howard Austen a pair of cocker spaniels they called Blanche and Billy. All four were working in Hollywood at the time, and they took a house together in Malibu Beach, where their dogs would disappear for the day, collected in the morning by a beagle who trotted down on his own from the north of the colony, returning at dusk, exhausted.

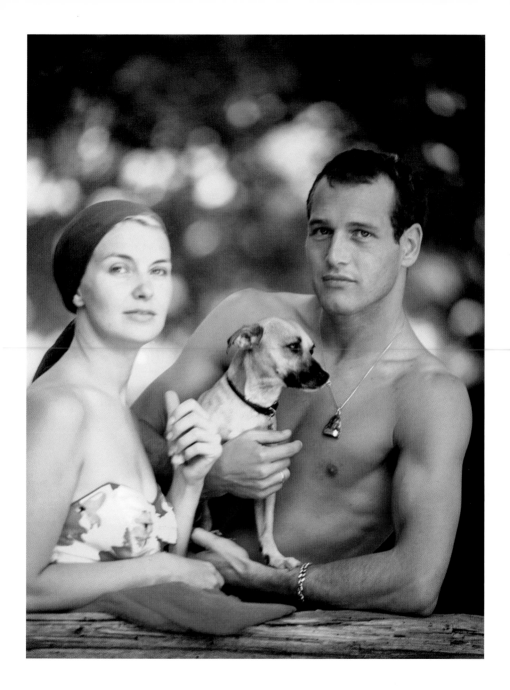

Elvis Presley with Sweet Pea, 1956

Dogs were a theme throughout the career of Elvis Presley (1935–77). He sang about them ('Hound Dog'), performed with them, and kept them as companions. As a child, brought up in poverty in Mississippi and Tennessee, Elvis wasn't allowed to keep a dog. However, his first public performance, at the 1945 Mississippi–Alabama Fair, was a rendition of 'Old Shep', a tearjerker about a boy and his dog; he was aged ten, and won fifth prize. Elvis's breakthrough came in July 1954, when he performed 'That's All Right' on the *Dewey Phillips Show* in Memphis; a few months later he had his first number one; and in 1956 he was outraging and inspiring a TV nation with his bump'n'grind rendition of 'Hound Dog'. Elvis is seen here with Sweet Pea, his first dog, in 1957. The little mongrel had belonged to his mother, whom he adored, and he took it over after her death that year. The singer subsequently acquired Great Danes, poodles, and in his final years a chow, who appeared on stage with him in 1975 at Las Vegas. Oddly enough, Elvis's manager, Colonel Parker, had a previous career with a troupe of performing dogs, and boasted of his ability to hypnotise them; one of his party tricks was to make members of the Presley entourage crawl around on their hands and knees, barking.

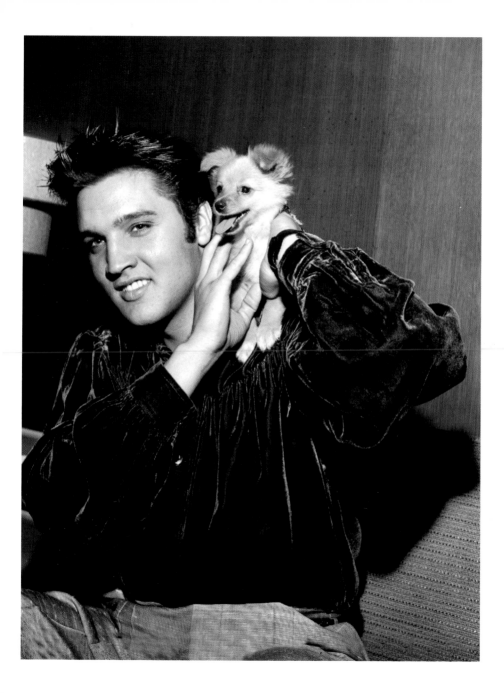

Gunnar Kaassen with Balto the wolf-dog, 1925

In 1925 there was an outbreak of diphtheria in the Alaskan town of Nome which posed a great danger to the lives of the town's children. The nearest vaccine available was in Anchorage, almost a thousand miles away, and the only means of transport the traditional sled. Led by Sledder Gunnar Kaassen, a relay of 'mushers' carried the serum from Anchorage to Nome in temperatures of −40°F. The world's media focused on the race against time, which climaxed on February 2 as Kaassen drove his team of dogs into Nome, headed by Balto, a wolf-Siberian husky cross. Balto became an international hero, and a statue was raised in his honour in Central Park, New York. Perhaps there was such a response to him because he reminded people of White Fang, the wolf-dog hero of Jack London's novel of the same name. After Balto died in 1933, his body was preserved and displayed in Cleveland's Natural History Museum, and in 1995 he was commemorated by an animated film, *Balto*.

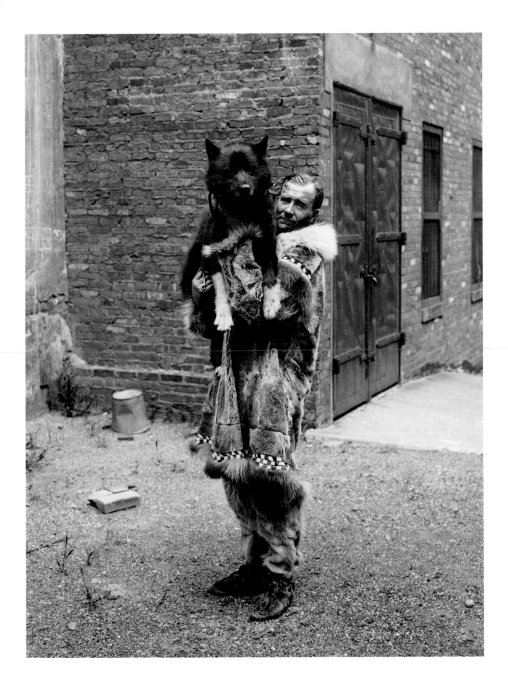

John F. Kennedy and **Dunker**, the dachshund pup, 1937

In 1937, the twenty-year-old John F. Kennedy (1917–63) was advised by his father to see Europe before the (in his view inevitable) war began. He set off on a tour with his best friend, Lem Billings, a Ford convertible and a diary, in which he noted that 95 percent of Americans were ignorant of the situation in Europe, that Hitler had a brilliant propaganda campaign, and (after witnessing a bullfight in Biarritz) that the French and Spanish are happiest at scenes of cruelty. He and Billings bought this little black and tan standard puppy – a 'dachshund of great beauty,' he recorded – in Germany for £8. Kennedy intended to take it home as a present for his girlfriend, but by the time they reached London, Kennedy's skin had broken out in an allergic reaction to Dunker, and the pup was given away. Later, when President of the United States, JFK and his wife Jacqueline had a number of dogs. They arrived at the White House in 1960 with Charlie, a Welsh terrier who appears in a famous photograph chasing after a stick thrown by the President. Whenever JFK and the First Lady wanted to have a frank talk in privacy they would simply take Charlie and Clipper, Jackie's German shepherd, out for a walk.

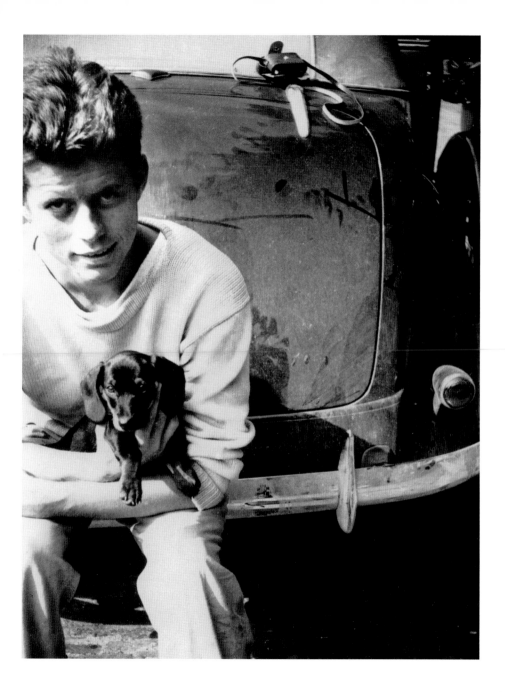

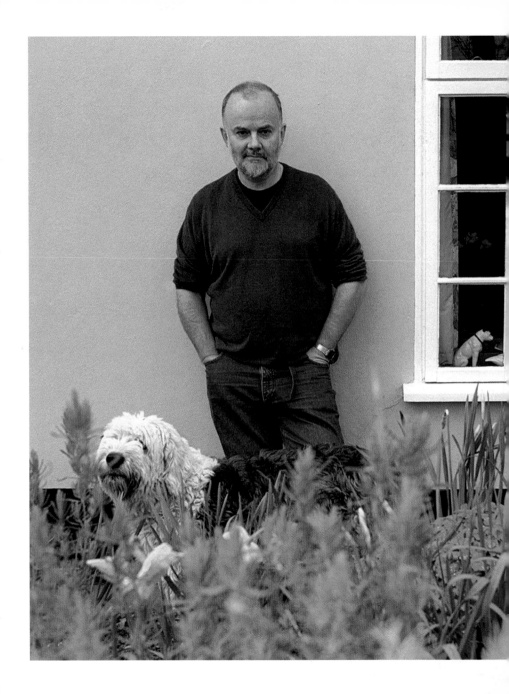

John Peel and his wife Sheila with Nellie, his Old English sheepdog, 1999

One of the many apparent contradictions about the legendary DJ John Peel (1939–2004) was between his taste in music (noisy, rebellious, urban) and his country lifestyle. In the last few years, he actually broadcast his famous Radio One show from 'Peel Acres', the Suffolk farmhouse he shared with his wife Sheila, four kids and numerous dogs and cats. He talked often about them all – Nellie the sheepdog who 'treated him like a god', Bernard the huge border collie – on *Home Truths,* his much-loved Saturday morning radio programme about 'ordinary folk'.

American pilots with an English bull terrier, waiting to 'scramble' at a Flying Fortress bomber station in Britain, 1942

This unnamed English bull terrier ensconced on the pilots' sofa was probably the regimental mascot, there to bring luck, but mascots were much loved companions, too. The breed, with its natural courage, was an obvious candidate for war service but this did not always work out as planned. In *Animals in War* (1983), Jilly Cooper gives two accounts of these idiosyncratic dogs. One is of a dog who deserted his post on a wet and windy night for the guardroom with its nice warm fire, and steadily refused his handler's entreaties to return to his job; with their thin coats, bullies were not cut out for guard duty. The other is the story of Bud, a brindle pup smuggled into France, when America joined the Allies in 1917, by 'Slats' Slattery of the 82nd Division, 325th Machine Gun Company. 'He was gassed in the Argonne and subsequently wore a special gas mask, took part in a big engagement on the Somme and learnt to flatten with the men when the shells came over... He managed to fight alongside his master throughout the war, returned home with him and lived to a fine age of thirteen. When he died, his heart-broken master wrapped Bud in his old campaign rug, placed him in a rough pine box and took him to a nearby war cemetery. While he was digging the grave, one of the cemetery staff strolled up and, sensing the ex-soldier's desolation, unearthed an old rusty bugle. As Bud was lowered in the grave, the last post rang out.'

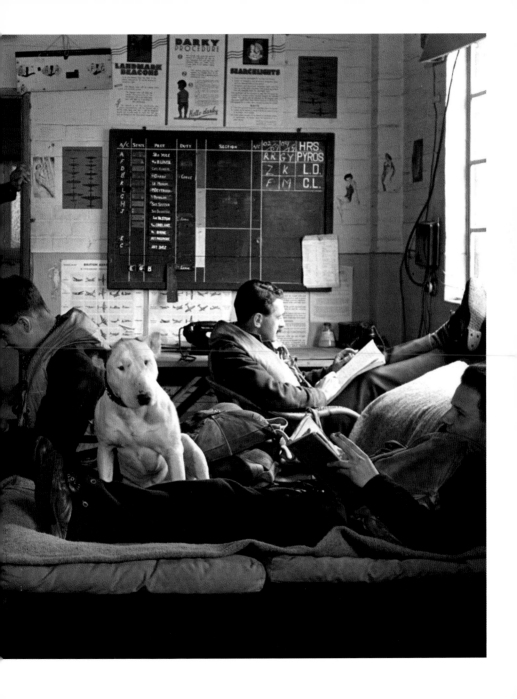

Sir Winston Churchill with Rufus his miniature poodle, 1951

Sir Winston Churchill (1874–1965) must have had a calming effect on animals, for Rufus his miniature brown poodle, a marmalade cat and a budgerigar called Toby were all invariably to be found on or near the great statesman when he was at Chartwell, his country home. Rufus ate in the dining room, a cloth being laid on the ground beside Winston, and no one could begin eating until the butler had presented the poodle with his meal. One night, the family was watching the film *Oliver Twist*, Rufus on his master's lap, when Bill Sikes was about to drown Bullseye, the faithful bull terrier. Churchill covered his dog's eyes with his hand – 'Don't look now dear. I'll tell you about it afterwards,' he said. This photo was taken in 1951, the year in which Churchill became prime minister for the second time.

Neil Young with his dog, 1971

Neil Young (born 1945) has kept dogs all his life, and on *Harvest Moon*, his most successful album in recent years, recorded a song about a favourite hound, 'Old King'. Performing it live, he would often pluck at a banjo and ramble for ten minutes or more about the dog – 'his real name was Elvis, but I called him King to avoid confusion' – before launching into the song proper. 'I've got a long way to go' is the key line of 'Old King', echoing how the dog disappeared off into the redwoods ('a-howlin' after deer') when Young and his band took a highway rest stop. The group waited for the dog for seven hours, but finally had no choice but to leave; in the hope that King might return, Young left his shirt behind.

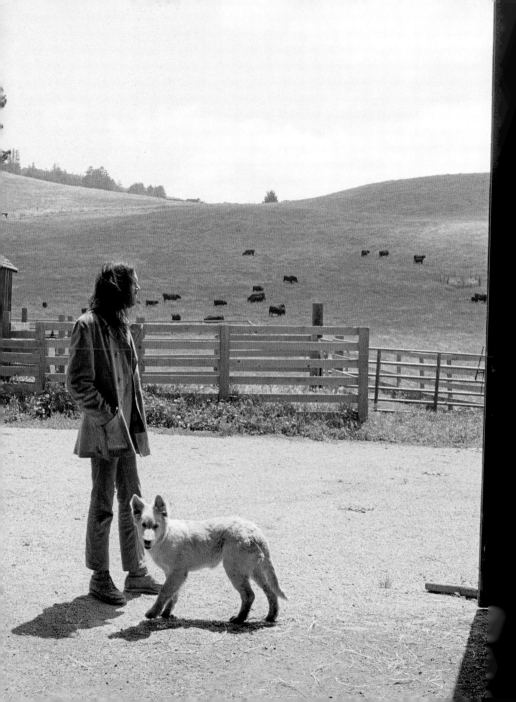

Dirk Bogarde with Candida, his English mastiff, 1966

Dirk Bogarde (1921–99) spent much of 1966 filming the spy movie *Modesty Blaise*, in which he played the villain, Gabriel. Bogarde had been a mainstream heart-throb in his youth, but in the 1960s he was moving into the art camp – or, with *Modesty Blaise*, the *Austin Powers* of its day, the camp camp. Bogarde was living at the time at Bendrose House in Buckinghamshire with Anthony Forwood, his partner and agent. Bendrose was a haven for the couple and their friends, and Bogarde in his memoir *Snakes and Ladders* writes of his happiness walking his dogs, the two corgis Sinhue and Bogie, and Candida the mastiff, across the fields; of house guests Ava Gardner, warming her bare feet on the dogs, and actress Kay Kendall demanding that husband Rex Harrison buy her a corgi of her own to love.

Craigie Aitchison with his Bedlington terrier, **Wayney,** 1975

Artist Craigie Aitchison (born 1926) is world's best known Bedlington owner – a position that had lain vacant since the days of Dorothy Parker, who, like Aitchison, was devoted to this lamb-like breed. Aitchison bought his first Bedlington, Wayney, after seeing the breed at Crufts in 1971 (a Bedlington won the terrier group for the first time in 1965), and the dogs have been immortalised in his screen prints and paintings ever since, appearing on fabrics, mugs and other gift items. The late and beloved Wayney was the model for Aitchison's *Dog in Red Painting* (1975, pictured here) and one of his successors, Angel, featured in the acclaimed 1982 *Crucifixion*, a gentle and sad figure standing a lonely vigil. The painter and printmaker studied law before attending the Slade School of Art in the early 1950s – where he bought himself a beagle – has had seven Bedlingtons and currently lives with Honey, Dusty and Christmas at his home in south London.

Harold Lloyd with his Great Dane, **Prince**, c.1927

The great silent movie star Harold Lloyd (1893–1971) is doing what the stars did in the 1920s – playing on the beach with a large pedigree dog. Rudolph Valentino was mocked by the British press for parading with a pair of Russian wolfhounds (borzois), but Lloyd was a hugely popular star, famed for the daring of his film stunts, and his Great Dane was regarded as very much a man's dog ('the war dog of the Danefolk, and worthy of men...'). Lloyd was certainly a dogs man and the kennels at his home, Greenacres, at one point housed sixty dogs, mostly Great Danes and St Bernards. In the pre-talkie 1920s, Lloyd's movies netted more money than Charlie Chaplin's and (fellow St Bernards lover) Buster Keaton's put together.

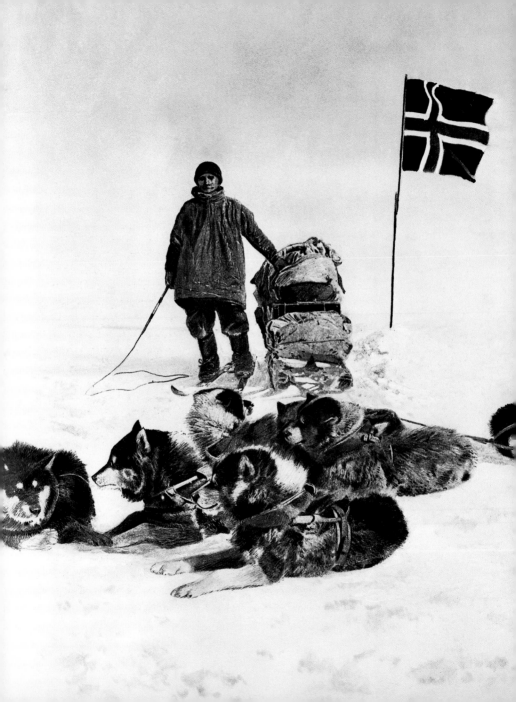

Oscar Wisting of the Roald Amundsen Antarctic Expedition with his dog team at the South Pole, December 14, 1911

'The dogs are the most important thing for us,' asserted Roald Amundsen, setting off for the South Pole. 'The whole outcome of the expedition depends on them.' In contrast to Scott's ill-fated team, which used ponies and motorised sledges, Amundsen put all his faith in dog sled travel, and accordingly set out from Norway on his ship, the Fram, with 97 Greenland dogs. The antics of the dogs and arrival of litters (there were 110 dogs when they reached Antarctica) provided most of the entertainment on board. Every one was named – there was Mikkel, Fox, Else, Major, Scalp and Pimp – and Amundsen's admiration for them rose the better he knew them. 'I have come to the conclusion', he noted in his journal, 'that in dealing with sledge dogs, one will benefit most if one assumes that they are at least as intelligent as oneself.' As they preferred the Greenland method of harness, in which they fanned out in order to pull the weight, they were allowed it, and they were fed on seal meat. 'I can safely say that the animals love us. With my own eyes I have seen men saving some of their own dinner portions to give their dogs when they showed signs of illness; only because they were so fond of them.' Nevertheless – in contrast to the ill-fated Captain Scott, who refused to kill his animals – Amundsen was ruthless in his plans, driving the dogs to exhaustion, and dispatching them when they could no longer function, leaving their carcasses on beacons, to eat on the return journey. In the event, Amundsen's party reached the Pole a month before Scott, and returned with all five members, and with eleven dogs.

David Hockney with his dachshunds, **Stanley** and **Boodgie**, 1995

In 1998 the British artist David Hockney (born 1937) published *Dog Days*, a book of pictures of paintings and drawings of his two dogs, Stanley and Boodgie. He had started painting them after his friend Henry Geldzahler, curator at the New York Metropolitan Museum, died in 1994. In the introduction he wrote, 'the dogs are my little friends ... It was probably my wanting a tender, loving subject,' and in an interview with *The Advocate* he spoke of how 'Much of it had to be done by observation. Now they lie stiller.' Hockney follows in a tradition of painters and dachshunds: Bonnard, Picasso and Warhol all kept them. He got Stanley first, in 1986, then Boodgie in 1989. 'They are not LA dogs. They haven't had nose jobs, or done commercials,' Hockney told *The Observer* in 1992. But was LA ready for the free and easy ways of his famous pair of teckels? Once he took them to his friend Dennis Hopper's house: 'Stanley went in and peed straight away in the middle of the carpet. You could see from the look on Dennis's face why he didn't make his career in musical comedy.'

Picasso and his dachshund, Loump, late 1950s

Pablo Picasso (1881–1973) was a great lover of dogs, and a keeper of lovebirds. In the 1950s, when this photo was taken, he had three dogs: Yan, a boxer; Perro, a handsome but incontinent Dalmatian; and Loump, this miniature dachshund. Each of them appeared in Picasso's works, Loump most famously occupying the foreground of Picasso's reworking of Velazquez's *Las Meninas*. Picasso's best known dog, however, was the trio's predecessor, an Afghan hound called Kazbek. Picasso kept Kazbek in Paris during the German occupation of the city in World War II and, unable to travel into the countryside, would take the dog for walks along the Seine, absorbing the images of the trees along the *quais*.

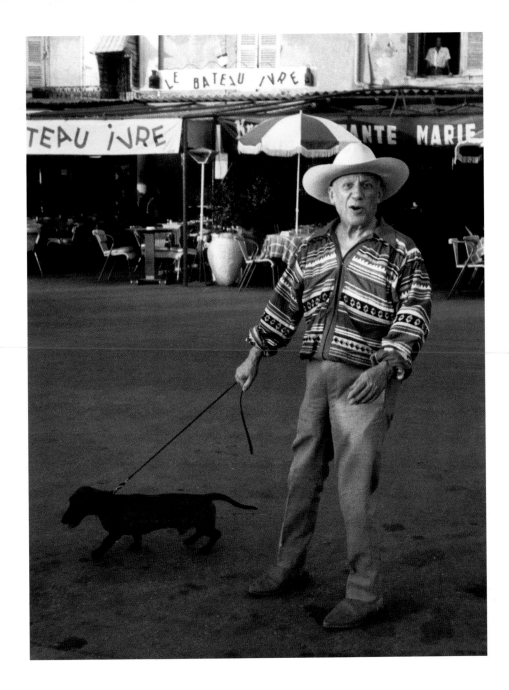

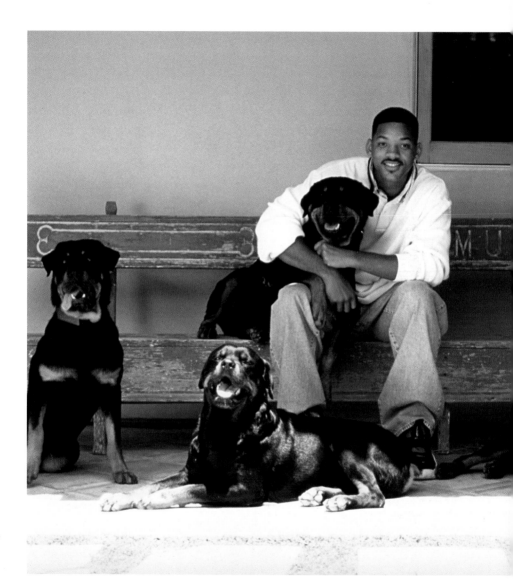

Will Smith with his Rottweilers **Indo** and **Zhaki**, and friends, 1996

According to big-breed trainer Cesar Millan, the actor Will Smith (born 1968) and his wife Jada Pinkett-Smith have learnt complete control over their five Rottweilers. Millan, who runs his famed Dog Psychology Center of LA in the heart of South Central Los Angeles, says that people must learn to fulfil the needs of their dogs if they are to live in harmony with their animals. His technique is to teach dogs in packs so they naturally follow their 'master'. That Smith has mastered Millan's dicta is obvious from this harmonious pack of Rotties. The star of such movies as *The Fresh Prince of Bel Air* and *Independence Day*, Smith acted memorably with a dog in the *Men in Black* movies, which feature Frank, the irascible talking pug. Interviewed in 2002, he commented on Frank's manners: 'My mother always said if you can't say anything nice, don't say anything at all. This whole thing has gone to his head.'

David Duchovny and Blue, his collie, 2000

David Duchovny (born 1960) has always had dogs, but it is Blue – known as 'Blue Duchovny' to the actor's fans – who is best known. A Border/Jersey collie, she lives with Duchovny, his wife Tea Leoni, their children and Leoni's dog, George, and during the filming of *The X-Files* she would accompany Duchovny to the studios. 'Half a mile away she would start jumping up and down, getting all excited, while I would start getting depressed. I'm trying to learn from her,' joked Duchovny, who for eleven years played FBI agent Fox Mulder in the cult conspiracy series. The simple nature of Blue, just happy to be with him, must have been a welcome antidote to studio life for the erudite Duchovny, who was doing a PhD at Yale on magic and technology in contemporary poetry and prose when he took up acting to pay the bills. 'I love dogs,' he once said. 'They live in the moment and don't care about anything except affection and food. They're loyal and happy. Humans are just too damn complicated.'

Coalminer and his rough-coated terrier, 1947

This coalminer at the Penallta Colliery in Caerphilly, South Wales, is taking his terrier to celebrate 'Vesting Day' – the nationalisation of the coalmining industry on January 1, 1947. After this date, the body running the mines was the National Coal Board. These terriers, originally used to chase out foxes gone to earth, were also used for ratting, which must have suited this jaunty little tyke. Penallta, an Edwardian-era mine, closed amid the Thatcher savaging of the coal industry, in November 1991.

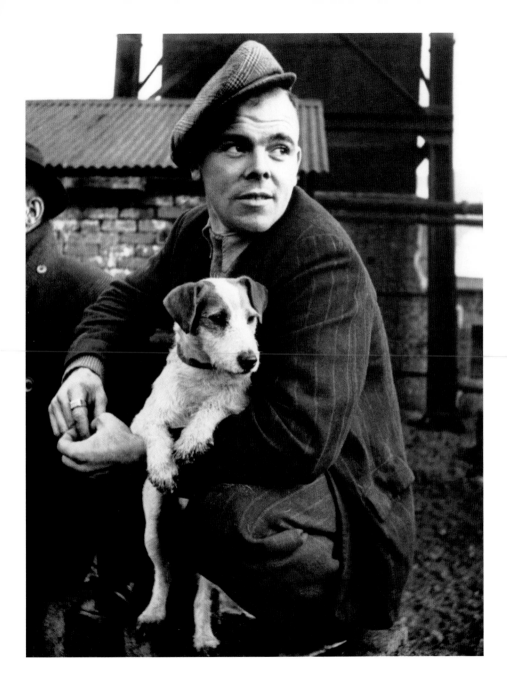

An Assinboin hunter with dogs, 1926

This Assinboin hunter, posing here with his dogs and booty of skins, was photographed by Edward S. Curtis as part of his *Encyclopedia of American Indians*, published between 1907 and 1930. 'The Assinboin are an off-shoot of the Yanktonai Sioux, from whom they separated prior to 1640,' he wrote. 'The southern branch has long been confined on a reservation in Montana, the northern is resident in Alberta. The latter is divided into two bands, which formerly ranged respectively north and south of Bow River, from the Rocky Mountains out upon the prairies.' Curtis's magnum opus was a visual documentation of every Native American tribe extant in the early twentieth century. Each sepia-tinted image was printed on vellum and the volumes bound in leather, but some critics today point out the staged nature of many of the pictures; they are idealised people in idealised landscapes. Nevertheless, the only domestic animal kept by aboriginal Americans were dogs, and this hunter is demonstrating what is thought to be the basis of domestication of the dog: as pack animal, hunting companion and guard – a relationship that is at least 12,000 years old.

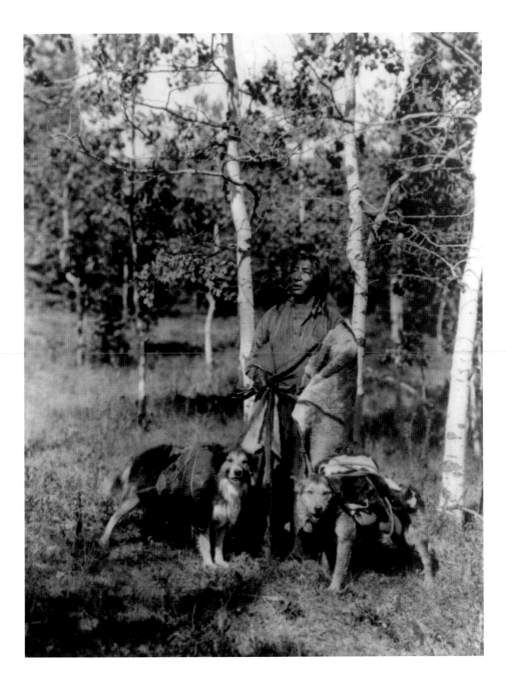

American sailors with **Buck** the St Bernard, 1955

This was a photo opportunity for the US Navy – the adoption of Buck the St Bernard as a mascot on the *USS Rochester*. The ship was docked in Los Angeles, where the big dog was a TV star, playing the part of Nell in a show called *Topper*. However, 'Buck' was a better name for the Navy as it recalled the famous canine hero – a big St Bernard and collie cross – of Jack London's *Call of the Wild*, an all-American tale of grit and spirit in the face of adversity.

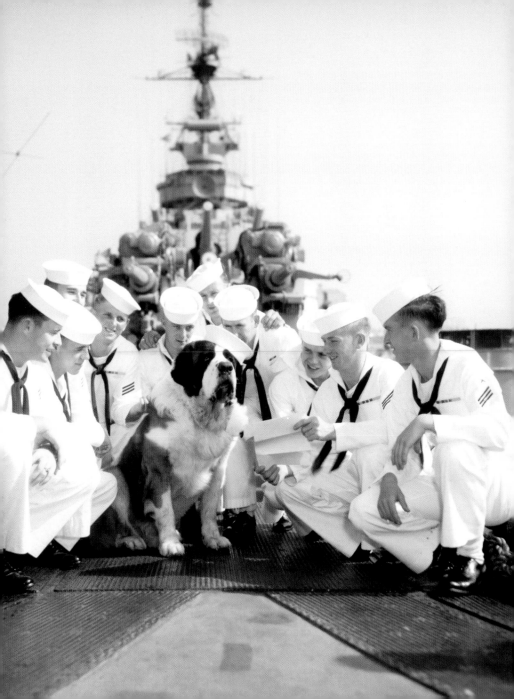

Pal, the rough-coated collie star of *Lassie*, with his trainer, Rudd Weatherwax (right), and film critic Dick Richards, c.1950

Children's classic *Lassie Come Home* was published as a novel in 1940. Its author was Major Eric Knight (1897–1943), a Yorkshire-born Hollywood screenwriter, who himself had a collie called Toots. MGM's movie version, starring the magnificent rough collie Pal, with Elizabeth Taylor and Roddy McDowall, was an instant hit on its release in 1943: a great tearjerker story of a dog bought by a bad-tempered old duke, who finds her way back to her original owner, a poor boy, all the way from the Scottish Highlands to Yorkshire. Pal was the undisputed star of the film, and a triumph for the dog-training team Rudd and Frank Weatherwax, one of Hollywood's unsung dynasties. Rudd and Frank's father, Walter Weatherwax, had arrived in Hollywood in the 1920s, and he and his seven children acted, did stunts (two of the boys doubled for Rudolph Valentino and his heroine in the horse chase scene in *The Sheik*), and trained dogs for pretty much every movie for the next fifty years. Other Weatherwax dogs include Toto in *The Wizard of Oz* (1939), John Wayne's collie in *Hondo* (1953), and Spike the mongrel in Disney's *Old Yeller* (1957), which many reckon the best dog movie ever made.

Sylvester Stallone cuddling one of his dogs, 1994

Dogs have played a big part in the life and career of Hollywood's great action star Sylvester 'Sly' Stallone (born 1946). As a struggling young actor and writer, he acquired Butkus, a bull mastiff pup, but in 1975, with 32 rejected film scripts and less than $100 to his name, he and Butkus were on their uppers and he could see no alternative to finding his dog a new home. Then an idea struck him: why not tell the inspiring story of the New Jersey club boxer Chuck Wepner, who had fought Muhammed Ali and gone 15 rounds with the heavyweight champion? The script was completed in three days and was snapped up, the Rocky legend was born and Butkus was safe. Stallone insisted that he himself play Rocky Balboa, the Italian-American underdog who loved animals and fought like a dream, and also cast the bull mastiff, by now a magnificent dog weighing 125 pounds, in the movie; he was credited as 'Butkus Stallone'. Stallone continues to keep dogs at his Hollywood home, most recently acquiring Flipper the labrador. Stallone's mother, Jackie, also keeps dogs, which she claims have clairvoyant powers. They predicted George W. Bush's election victories in 2000 and 2004.

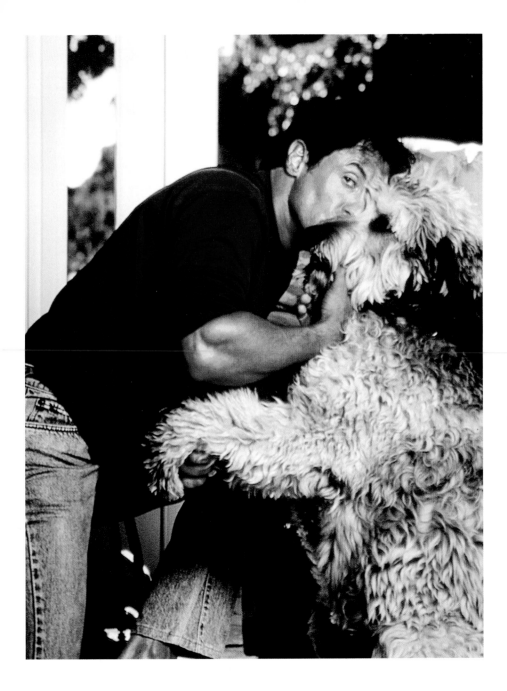

The band **America** with a farmer and his Australian blue heeler, 1973

In the summer of 1973, folk-rock band America were recording their third album, *Hat Trick*, in California, having enjoyed a huge hit with 'Horse with No Name'. The trouble was that, although the trio were indeed American, they had all been brought up in England, previously recording in Dorset. This picture, taken by rock photographer Henry Diltz, sets them in the context they needed – hanging out on an all-American porch with a Stetson-wearing farmer and his cattle dog. This is an Australian blue heeler, a mix of the blue merle smooth-coated collie and the dingo, bred by European immigrants in Australia; their loyal nature and great beauty have led to them being called the best cattle working dogs in the world. The dog gives just the American roots and strangeness that the picture required.

Roscoe 'Fatty' Arbuckle with Luke, his Staffordshire terrier, c.1920

'Fatty' Arbuckle (1887–1933) was a classic American silent movie actor, and Luke, his companion from 1913 to 1926, one of the first great canine film stars. Luke was what was then called an 'English Pit Bull' (a breed renamed Staffordshire terrier by the American Kennel Club in 1936) and he had that combination that makes bull terriers such good actors: intelligence, humour and a great sense of timing. Luke and Fatty met on the set of *Lane, Speed and Thrills*, where Arbuckle's wife, Minta Durfee, was dangling over a cliff edge. The producer Wilfred Lucas promised her a six-week-old brown and white puppy if she kept her nerve. She and Roscoe called the dog Luke and he became a member of the Keystone team, debuting in 1915 in Mabel and Fatty's *Wash Day* and eventually earning $150 a year. As befits a bull terrier, he was fearless, ascending ladders, scrambling across roofs, jumping from great heights, even leaping from one moving car to another. After Arbuckle's trial and unanimous acquittal for rape in 1922, which effectively put an end to his career, Luke worked with Buster Keaton and Al St-John; but he is remembered most affectionately for his performances with Arbuckle.

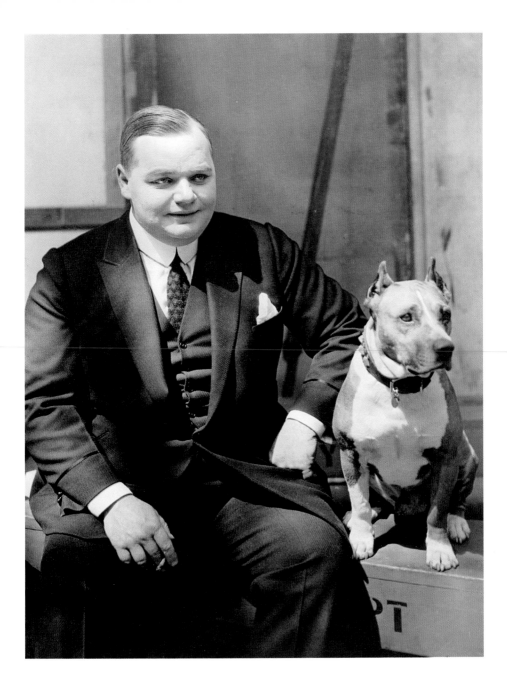

Mikhail Baryshnikov and his Border collie, Tim, 1986

This animated portrait shows Mikhail Baryshnikov (born 1948), the greatest male dancer of his generation, playing with his Border collie, Tim. Baryshnikov was born in Riga, Latvia, and joined the Kirov Ballet as a teenager. However, frustrated by the lack of challenges in Soviet classical ballet, he defected to the US in 1974. He made his New York debut as Albrecht opposite Markarova's Giselle, receiving a thirty-minute ovation, and later became artistic director of the American Ballet Theater, as well as establishing his own modern dance company, White Oak, and acting – most famously as Alexander Petrovsky in *Sex and the City*. He talks often of his passion for dogs, and is a big promoter of adopting rescue dogs. His current dog is a boxer, Maggie, whom he found on a recent trip back to Latvia.

Marky Mark Wahlberg and German shepherd, 1991

Actor Mark Wahlberg (born 1971), aka Marky Mark, rapper with the Funky Bunch, is photographed here by Annie Liebovitz. The writer Marjorie Garber suggests in *Dog Love* (1997) that this is a pastiche of a famous advert by Coppertone, in which a dog playfully attempts to tear off the bottom half of a model's bikini. Wahlberg was an obvious candidate for such a take. His trick of dropping his trousers on stage, showing off his underpants and grabbing his crotch with his hand, had caused a sensation in 1991. On the strength of it, Calvin Klein signed him up to model his famous underwear along with supermodel Kate Moss and he became a global pin-up for women and gay men. Not surprisingly perhaps, in an act of supreme narcissism, Marky Mark published a book dedicated to his penis in 1992.

Major Frank Buckley with his Welsh terriers, outside Wolverhampton Wanderers' ground, Molineux, c.1935

Major Frank Buckley (1883–1964) was one of English football's great mavericks. A tough centre half, he played in the old First Division, and once for England, before entering the Army at the start of the Boer war. During World War I he led the Footballers' Battalion, a unit entirely made up of ex-pros. After the war, 'The Major', as he was known to all, set about revolutionising English football management, most famously at Wolves, where he blooded a succession of young, untested players (the Buckley Babes), training them with the help of ballerinas, a psychologist and monkey gland injections. Although he never quite won the trophies to ensure a place in the football history books, he was the top earner in pre-World War II football and affected an upper-class military image in impeccable Oxford bags, as in this photograph with his no doubt perfectly trained terriers.

Edwin Brough with one of his bloodhounds, c.1900

In 1888, Edwin Brough (1844–1924) sent Burgho and Barnaby – two of his magnificent bloodhounds – from Scarborough to London to help in the search for the murderer dubbed Jack the Ripper. Brough was a pioneer breeder and founder of the Bloodhound Association, and his team of dogs was legendary, so it might be imagined that a nation of animal lovers would delight in the thought of man's greatest friend assisting the capture of the loathsome Ripper. Not a bit of it. Londoners and the press mocked the very idea: in an age of modernity, why turn to medieval methods? The dogs trained in Hyde Park, but when the body of the last victim, Mary Jane Kelly, was found in Whitechapel on November 9, a delay in getting the dogs to the scene meant that the scent had gone cold and blurred with others. Despite this failure, Burgho and Barnaby set the precedent for dogs working with the British police, which began officially in the 1930s. Brough was also approached by American police, who wanted to cross his bloodhounds with the Cuban hound, but as these were bred both to track men and bring them down, he refused to become involved.

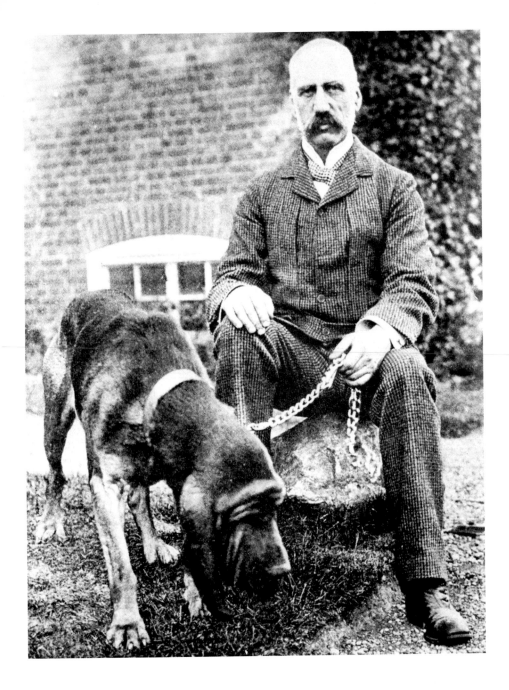

Richard Burton with his Pekingese, Een So (on the right) and Elizabeth Taylor's Shi Tzus, 1968

Richard Burton (1925–84) and Elizabeth Taylor were the world's most famous and photographed couple in the 1960s – a decade in which they kept numerous dogs, particularly Pekes and Shi Tzus. These were all notoriously un-house-trained and when in 1968 the Burtons came to London and moored their dogs on a yacht in the Thames to avoid quarantine, the bill for replacing the boat's Wilton carpets was nearly £1000 a month. Burton conceded that if there was a bare room except for one tiny rug, they will 'crap on that rug, taking turns'. Nonetheless, he was devoted to them, and especially to his Pekingese, Een So: 'I love that old Chinese lady,' he wrote anxiously in his journal when she was ill.

Richard Byrd with his terrier, Igloo, 1928

The American explorer and aviator Richard Byrd (1888–1957) was accompanied by Igloo on his first Antarctic expedition of 1928–30, the dog wearing a 'little union suit and fur cap' to keep warm aboard the *City of New York*. Roald Amundsen had advised Byrd to 'take a good plane, plenty of dogs and only the best men'. Ninety-five working sled dogs accompanied Byrd and his team to the South Pole. Some of them died in order to feed the rest of the dogs, others in dog fights, and seventeen had to be shot. But the remaining sixty were taken on board ship to return to the USA. Byrd was honoured by the ASPCA and the dogs hailed as American heroes. When one of the veterans, a husky called Unalaska, was run over in Monroe, Louisiana, three thousand children took part in his funeral and he was buried in land consecrated to the war dead.

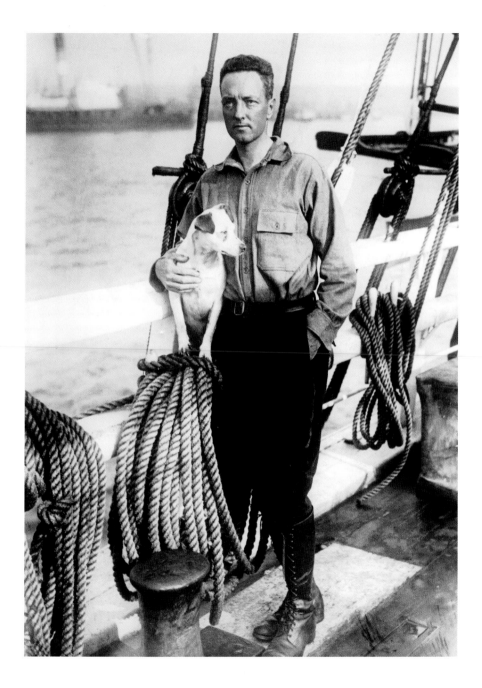

Truman Capote and his bulldog, Charlie, 1953

Truman Capote (1924–84), bestselling author of *Breakfast at Tiffany's*, journalist, wit and man-about-town, was working with film director John Huston on his 1953 film *Beat the Devil* when he began an arm-wrestle with Humphrey Bogart. It was an odd pairing but, as Huston described it, Capote, effeminate, camp and scary-tongued as a 'bulldog', wrestled 'husky' Bogart to the ground. At the end of filming, Huston's colleague Jack Clayton presented Capote with this lovely English bulldog. Capote named him Charlie J. Fatburger, and spoilt him rotten. After the dog died, he was succeeded by another bulldog, Maggie, whom Capote once flew to Europe in a private jet, along with a tame crow and a cat, to accompany him on a skiing trip to Verbier.

Robbie Williams and Sid the wolf, 2003

In the recent biography *Feel*, British pop singer Robbie Williams (born 1974) tells the author Chris Heath 'I've got a wolf.' And here he is – a wolf-dog named Sid (after the comedian Sid James rather than Sid Vicious, apparently). Sid didn't come from the wild, where wolves are now close to endangered, but from a prestigious pet store in Los Angeles, which sources exotic animals for its clientele. He sleeps in a crate beside Williams's bed and has garnered a certain mystique for the singer: Mark Owen, his old mate from Take That, was shocked to find himself not just face to face with the Williams wolf, but stroking it. Robbie, who, according to Heath 'adores' dogs, had previously tried his hand with a Rottweiler and then two Great Dane pups, the latter lasting just a night after overwhelming a tiny flat with their 'turds'. With plenty of room in America, however, Williams has been able to indulge his canine instincts. First he got Sammy, a pit bull-Labrador cross rescue, then a German shepherd called Rudy (named after The Specials' song 'Message to You, Rudy'), and finally, Sid. The fact that Sid looks remarkably like a husky begs the question: is this is a wolf, a wolf hybrid, or is the singer having an elaborate joke at the expense of the media?

James Dean with a Border collie, 1955

In February 1955, James Dean (1931–55) visited his uncle Marcus in his home town, Fairmount, Indiana; photographer Dennis Stock went along and took this picture of him with a farm dog. As a child, Dean had had a dog called Tuck and there is no doubt, looking at this photo, that he was at home with dogs. 'There are a lot of things I learned from animals. One was that they couldn't hiss or boo me,' he said. 'I also became close to nature, and am now able to appreciate the beauty with which this world is endowed.' The following month, *East of Eden*, directed by Elia Kazan, was released, Dean was nominated for an Oscar, bought himself a Porsche in which to compete in races, and started working on *Rebel Without a Cause*. That same September he was killed in a car crash.

Cypress Hill's DJ Muggs with his American pit bull, 1995

DJ Muggs (born 1968) is pictured here with his American pit bull. Born Larry Muggerud, Muggs was breakdancing at 14, moved to Los Angeles in 1984 and soon found himself DJing for his friends B-Real and Sen Dog. The trio formed Cypress Hill in 1988 and the hip-hop band went on to huge success, with over fifteen million albums sold worldwide and numerous awards for their rap-rock sound. As a producer, DJ Muggs has worked with artists as diverse as Ice Cube and Depeche Mode, while beginning a solo career. 'I like my music smoked-out. Dusted. Slow. Dark. Like a small, dingy club with mad cigarette smoke. Whisky. You know what I mean?' His choice of dog superficially compounds the gansta-rapper stereotype, but 'pit bull' is a broad term. This dog is closer to Fatty Arbuckle's American Staffordshire terrier (see p.56), with his broad chest, cropped ears and short stop, than the rangey, non-specific pit bulls used as guard and fighting dogs that created such anti-bull-terrier frenzy in Britain and America in the 1990s.

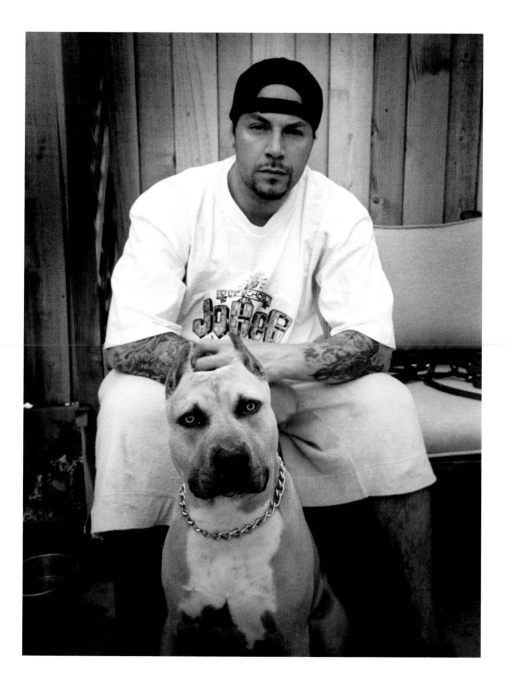

Kirk Douglas swimming with one of his golden Labradors, 1991

One of Hollywood's greats, Kirk Douglas (born 1916) swims with one of his two Labradors – who are called Foxy and Denny – in his pool at home in Los Angeles. The photo was taken in 1991, a year in which Douglas had been the sole survivor of a helicopter crash, suffering serious back injuries. Perhaps swimming with his dog was an encouragement and helped in the healing process. Douglas was born Issur Danielovitch, in New York, of Russian immigrant parents, and rose to fame (after doing service in World War II) as an epic Hollywood hero; it was a position that he used, with courage, to help end the infamous McCarthyite 'Blacklist' of 'communist sympathisers'. Now the patriarch of an acting dynasty, Douglas starred in the 2003 movie *It Runs in the Family* with his son Michael, and grandson Cameron Douglas.

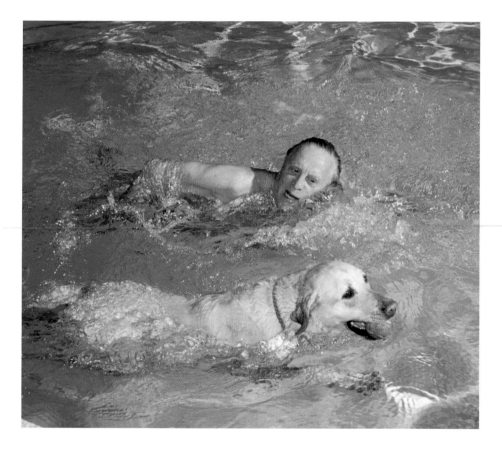

Edward VII with his wire-haired fox terrier, Caesar, at Balmoral, c.1903

Edward VII (1841–1910) was brought up by an intensely dog-loving mother, Queen Victoria, and married off to an equally canine-oriented wife, Princess Alexandra of Denmark. The princess's many dogs spilled over the furniture and grounds of their country residence, Sandringham, providing her with some company while 'Bertie' philandered. In his later years, however, Edward was famously devoted to Caesar, his wire-haired fox terrier. The dog was a gift from the dog-breeding Duchess of Newcastle in 1902 – a champion fox terrier could then cost as much as £375 – and slept in a chair by his master's bed, to the loathing of his mistress, Violet Keppel. Caesar also blithely transgressed British quarantine laws, worried statesmen's trousers like a rat, was best friend to anyone who fed him at table and was ruthlessly standoffish to all but the king out of doors. He was bathed every day as, like any normal terrier, he was inclined to be whiffy. Caesar was immortalised by his faithful behaviour during his master's funeral. He trotted behind the gun carriage, led by the royal gillie Maclean, accompanied by the royal family, nine kings and numerous princes and nobles from all four corners of the earth. Vita Sackville-West remembered how 'everyone cried when they saw the King's little dog following the coffin'.

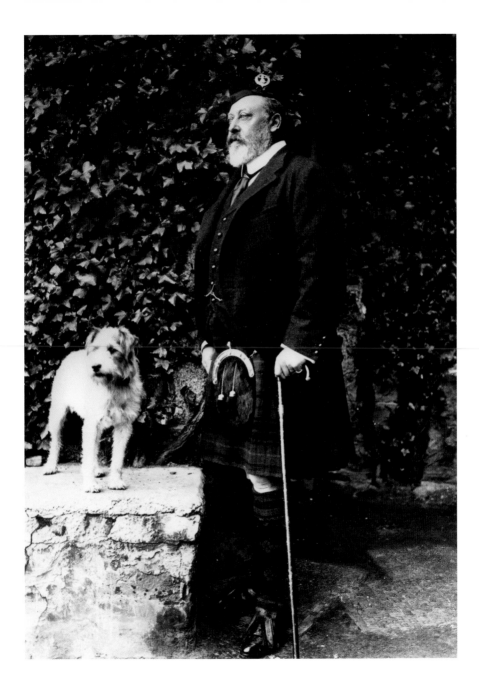

President Clinton with his Labrador, **Buddy**, 1997

Into his second term as President of the United States, and with Chelsea leaving home for college, Bill Clinton (born 1946) and his wife Hillary decided to get a dog, and opted for a Labrador. It seemed an ideal choice in temperament and size for the White House, and Hillary found a beautiful chocolate-colour pup, who Bill named after his late great uncle, Oren 'Buddy' Grisham, a dog trainer who had allowed him to play with his hunting dogs as a child. Buddy fitted in immediately; he slept at the president's feet, loved meeting people, played up to the cameras and generally enjoyed himself. When the Monica Lewinsky scandal broke in 1998, Buddy was, according to Hillary, the only member of the Clinton family who was willing to keep the president company. He left the White House in 2000 with the Clintons and settled with the family in Chappaqua, where he died in 2002 – 'a loyal companion who brought us much joy. He will truly be missed.'

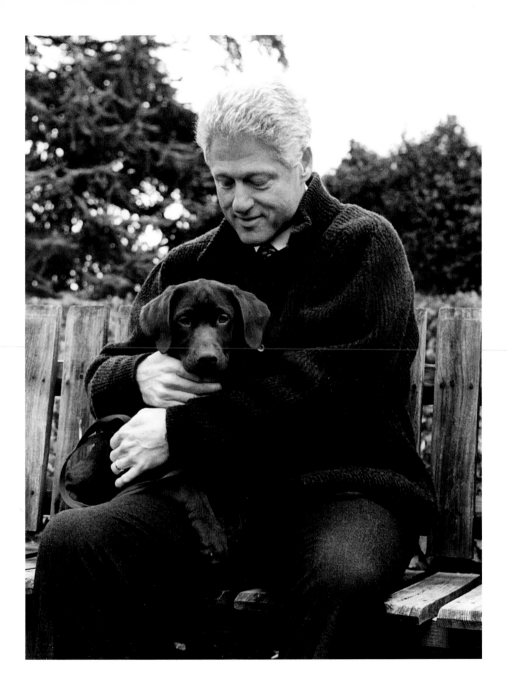

Ian Fleming and two mongrels, mid-1950s

It is said of Ian Fleming (1908–64) that he didn't like dogs after he was bitten by one of his father's basset hounds at the age of six. But this picture tells another story. It shows the author clearly at ease with a couple of mongrels, using the Remington typewriter on which he created the James Bond novels. The photo was taken at Goldeneye, the home he built in 1947 on Jamaica's north coast. Noel Coward, who was his tenant there for three months, called it 'Golden Eye, Nose and Throat' because it reminded him of a hospital.

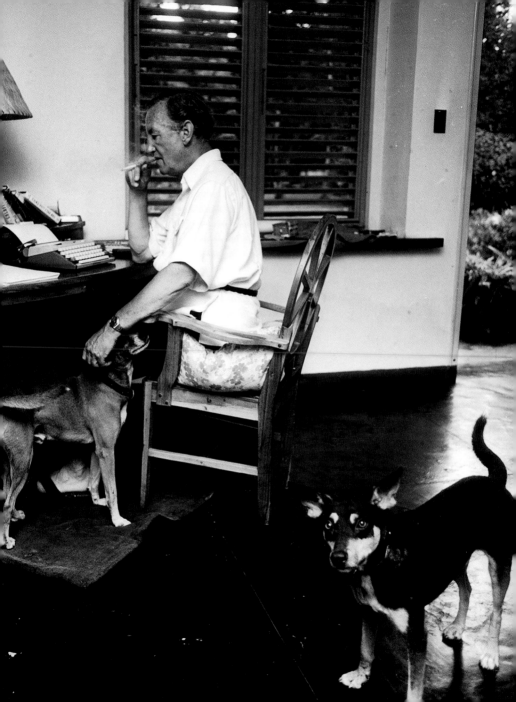

Errol Flynn with Arno, his miniature schnauzer, 1941

Actor Errol Flynn (1909–59) had an über-masculine screen image, but when it came to animals he was a softie, and his heart was broken by the death of Arno, his miniature schnauzer in 1941. 'The little mutt', as his owner affectionately knew him, had accompanied Flynn to premieres and parties, restaurants and clubs, even shared his bed. On one occasion a bartender, sick of Arno cocking his leg outside his building, screwed an electrified metal plate to the spot. When Flynn discovered what had made Arno yelp in pain, he seized the man by the back of the neck, dragged him outside and, so the story goes, made him pee on the same spot. He always maintained that the best friend he ever had was Arno, who tragically was lost overboard on Flynn's yacht. Flynn later went on to breed champion Rhodesian ridgebacks – so-called lion dogs, which he imported to America after hunting in Africa with Hemingway.

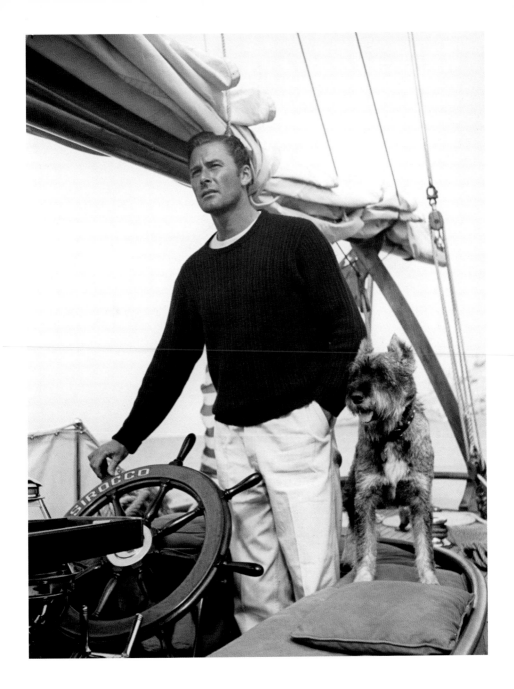

Bob Hope and a black miniature poodle, 1950s

'Golf is my real profession – show business pays my green fees,' quipped Bob Hope (1903–2003), the master of the ad-lib, pictured here at a charity Pro-Am tournament with one of his miniature poodles. Hope and his wife Dolores had three poodles around this time – Ginger, Bebe and Baxter – and with their quick wit, native intelligence and sense of fun they were perhaps his perfect dogs. The Hopes never lost their affection for the breed and into their 90s (they were married for almost 70 years) they kept two poodles, along with two white German shepherd dogs.

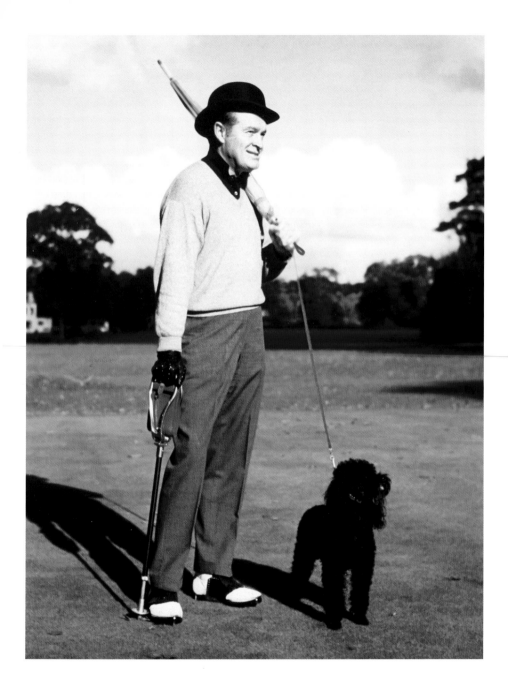

Sigmund Freud and **Jo Fi**, his chow, 1935

Sigmund Freud (1856–1939) is pictured here in his Vienna consulting room with his beloved chow, Jo Fi. She joined the Freud household in 1929, soon after the death of Lun Yug, his first chow, whom he had been given as a present two years before. Freud and the dog were inseparable for the seven years of her life, and he allowed the dog to remain during his therapy sessions, as he found her presence a calming influence on patients. 'One can love an animal like my Jo Fi so deeply,' he wrote; 'affection without ambivalence... a feeling of close relationship, of undeniably belonging together.' Chows are famously 'one-man dogs' and their calm, single-minded, loyalty touched Freud: 'They love their friends and bite their enemies, unlike people who are incapable of pure love; they always have to mix love and hate in their object relations.'

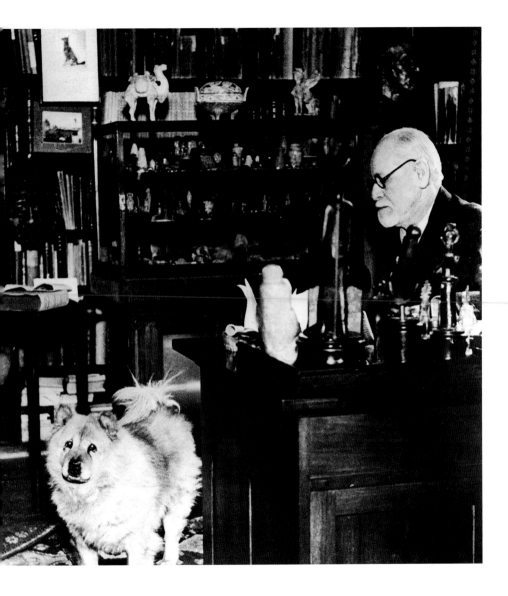

Clark Gable with his Irish setter, Lord Reilly, c.1941

This glamorous photograph shows the 'King of Hollywood' Clark Gable (1901–60) and his prizewinning Irish setter, Lord Reilly of Redwood, on the set of *They Met in Bombay*. By all accounts, this was the happiest time of the actor's life: a huge star on the back of *Gone With The Wind*, he had recently married Carole Lombard and the couple were enjoying an idyllic life together on a ranch in California's San Fernando Valley, looking after cows, hens and a couple of dogs. Gable loved duck and upland bird shooting, and the Irish setter, with his terrific scenting and pointing ability, would have been the perfect companion at these events. As well as Lord Reilly, there were Commissioner the dachshund and a boxer called Toughie, who was supposedly the guard dog. However, when Gable was disturbed by a burglar trying to steal from his prized gun collection, Lombard inspected the tracks in the sand and concluded that Toughie had spent the night in the garage with the miscreant. 'You had better change his name to Sweetie,' she told Gable. Tragically, in 1942 Lombard was killed in an air crash along with her mother, Otto Winkler, Gable's best friend, and fifteen young Army pilots. Gable went off to the war, enlisting in the Air Force, but later remarried and returned to the ranch, where he lived until his death.

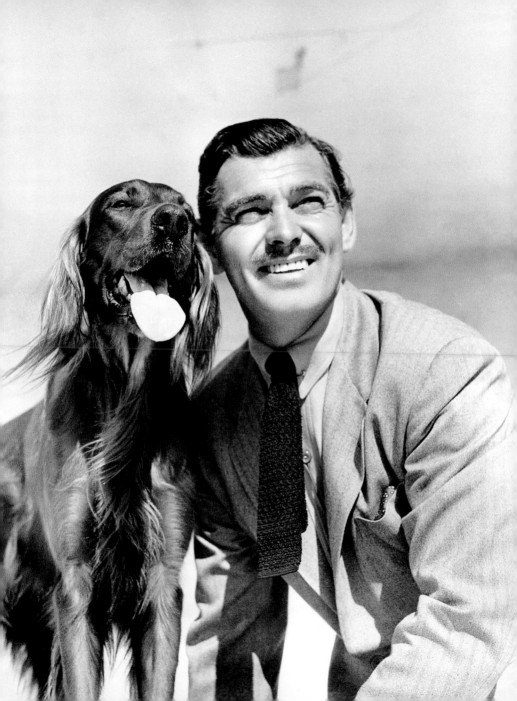

Ernest Hemingway with his black Labrador gundog, 1942

It is no surprise that Ernest 'Papa' Hemingway (1899–1961), America's archetypal man-of-action writer, kept gundogs. The novelist loved hunting with his buddies and this is one of a series of pictures taken by Lloyd Arnold when Hemingway was shooting with film star Gary Cooper in Sun Valley, Idaho; the photos show both men accompanied by black Labradors. Hemingway also famously had a spaniel called Black Dog, and liked to tell a story, presumably apocryphal, about how he himself had fought with a Great Dane who had attacked the dog, tearing open his mouth, gouging out his eyes and killing him with his bare hands. Hemingway was a little more cautious in Cuba in 1958, keeping out of the way when Batista's soldiers invaded the grounds of his home, the Finca Vigia, looking for a rebel, and shot and killed his dog, Machakos, who was defending the property.

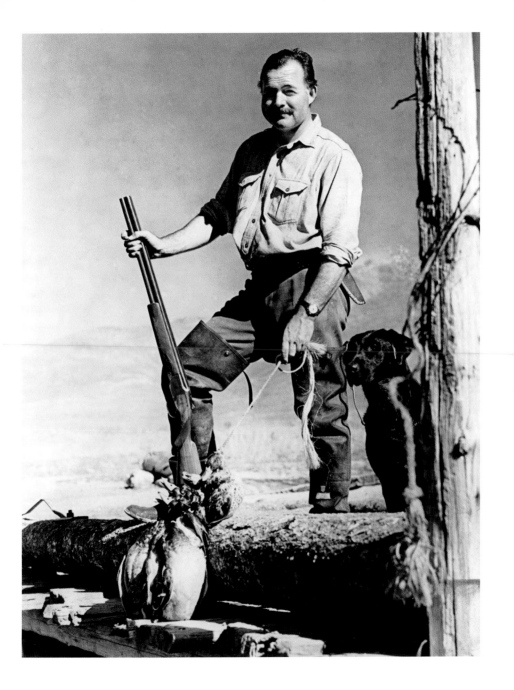

John Huston dancing with his collie, Irish wolfhound and Shi Tzu, 1960

Eve Arnold took this picture of John Huston (1906–87) at the director's home in Galway, Ireland, in 1960. He already had twenty films behind him, including *The Maltese Falcon*, *The Treasure of the Sierra Madre*, *Key Largo* and *The African Queen*, and was to make as many again, despite the presence, that year, of Peter O'Toole as a house guest. O'Toole recalled one morning after a night before: 'John in a green kimono with a bottle of tequila and two shot glasses. He said, 'Pete, this is a day for gettin' drunk!' We finished up on horses, he in his green kimono, me in my nightie in the pissing rain, carrying rifles, rough-shooting it – but with a Shi Tzu dog and an Irish wolfhound, who are of course incapable of doing anything. And John eventually fell off the horse and broke his leg! And I was accused by his wife of corrupting him!'

Paul McCartney and Martha, his Old English sheepdog, c.1967

Martha the Old English sheepdog was perhaps the most famous dog of the 1960s, immortalised in McCartney's song 'Martha My Dear' on The Beatles' *White Album*. She lived with Paul McCartney (born 1942) and his girlfriend, the actress Jane Asher, in their home in St John's Wood, where she had her own trap door, which let her into the garden. Biographer Hunter Davies reported in *The Beatles* (1968) that Martha would be taken for walks on Primrose Hill and Regent's Park by McCartney, who would rush past his fans, jump into the car with her and head to the park. Once there, he would put up his collar and walk in the more remote areas, stopping to chat to elderly dog owners who were more interested in the enormous Martha than in Paul. In 1999, he told an animal magazine that 'she was really good for me; we were good for each other. I remember John Lennon coming round and saying, "God, I've never seen you with an animal before." I was being so affectionate it took him back, he'd not seen that side of my character. Because you don't do that with humans; not as obviously anyway.'

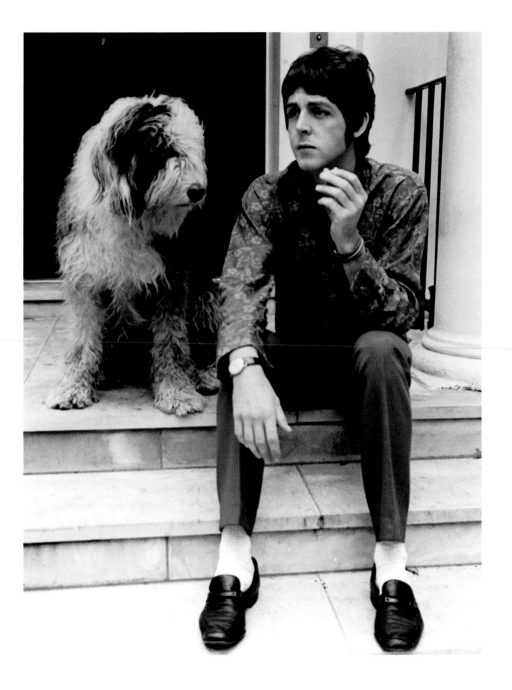

Mick the Miller with unknown handler, c.1930

Mick the Miller (1926–39), the legendary racing greyhound, had nine-teen consecutive wins in 1930. The brindled champion had an uncanny knack of being last at the first bend, reached third in the final bend and 'overtook on the outside and got up to the line to win by a nose'. This brilliant dog was bred by an Irish priest, Father Brophy, and owned by Mr Sidney Orton, and such was his celebrity he went on to appear at the London Palladium before he retired. After his death, at thirteen, he was stuffed and put on show at London's Natural History Museum.

Alexander McQueen and Juice, his English bull terrier, 1998

Alexander McQueen (born 1969) is the most talented and interesting fashion designer among Britain's 'new generation' – a genius whose unique vision and tailoring know-how led to a meteoric rise in the 1990s, working with Gigli and Givenchy, before he launched his own label at the end of the decade. Hailing from London's East End, with parents who were chow chow breeders (early photographs show him cuddling these striking dogs), McQueen is still based in the east's Hoxton area. In 1995 he got his own first dog, a handsome Staffordshire-cross he called Minter, from Battersea Dog's Home, and in 1997 he found her a companion – the gorgeous red and white Juice, just about a year old in this picture for *Dogs Quarterly* magazine. Juice was the daughter of a Hoxton bull terrier called Bonnie, and McQueen and his friend, stylist Katy England, went along together to choose two sisters; England called her puppy Mouse (see *Women and Dogs*). Minter and Juice have both appeared on the catwalk with their owner, and Minter gets on with both sisters. Juice and Mouse, however, don't get on at all.

James Ellroy and his English bull terrier Barko, 2001

Cult crime writer James Ellroy (born 1948) once summed up his life as follows: 'Boy's mother murdered. Boy's life shattered. Boy grows up homeless alcoholic jailbird. Jailbird cleans up and writes his way to salvation. Jailbird becomes the Mad Dog of American Crime Fiction.' Mad about dogs, too, you might add – for as Ellroy puts it, 'dogs are an obsession with me', and in particular his English bull terriers Barko and Dudley ('a cross-species heterosexual' who loves women and has 'stalker tendencies'). The acclaimed author of bestsellers including *The Black Dahlia* and *LA Confidential*, Ellroy described a fantasy about dogs to writer Robert Birnbaum: 'I'd like to get two bull terriers and walk them across Kansas City Country Club and let them shit on the greens. I know how appreciated that would be.' So why does he like the so-called gladiators of the canine species? 'Bull terriers have that wedge head. They're very friendly. They're very intelligent. They're very durable. They love humans... they have a tendency to scrap with other dogs. But they're great. They're great kids' dogs. They're just beautiful, beautiful animals.'

Francis Clark, Royal Kennel Keeper, with Queen Victoria's dogs, c.1879

'Francie' Clark, seen here with some of Queen Victoria's dogs at Balmoral, has often been mistaken for his cousin, John Brown, 'the Queen's Highland Servant' and friend, made famous to modern audiences by the film *Mrs Brown*. He is photographed here with four dogs: Fern the collie and Waldmann II the dachshund are seated on the plinth, while collie Noble IV and smooth-haired fox terrier Wat stand on the steps. Fern, Noble IV and Waldmann II appeared in a group portrait, *Queen Victoria and Princess Beatrice and a Group of Dogs at Windsor*, painted in 1877 by Charles Burton Barber. Visits to the kennels were part of daily life for the Queen and her family at Windsor and Balmoral, and Francie's duties included drying off the dogs before they entered the house. After John Brown died in 1883, Clark became the second 'Queen's Highland Servant' – a position that enraged her son, later Edward VII, who already felt that Brown had undermined his role as head of the family after the death of his father in 1861. When Victoria died in 1901, there were 88 dogs in her kennels at Windsor. Edward closed them and moved the dogs to his own kennels at Sandringham.

Paul Robeson with a wire-haired fox terrier, 1925

In this pastiche of Francis Barraud's famous painting, *His Masters Voice*, with the terrier Nipper, the great Paul Robeson (1898–1976) poses with a jaunty wire-haired fox terrier whose name is unknown. Robeson was 'the most popular man in Harlem', a former barrister who had left the profession because of racism and was singing at The Cotton Club as well as working as an actor. His theatrical debut had been in Mary Hoyt Wyborg's awful *Taboo* (1922) and he went on to play *Voodoo*, as it was renamed in Britain, opposite the flamboyant diva Mrs Patrick Campbell (with her inevitable little dog in tow). She encouraged improvisation, adored Robeson, and would loudly whisper, 'Do sing again – you're much better than the play.' Back in New York, Robeson and accompanist Larry Brown held their first concert on April 19, 1925 at the Greenwich Village Theater. In July 1925, following sell-out concerts, Robeson and Brown made their first recordings for Victory Records, 'Swing Low, Sweet Chariot' and 'Bye and Bye', selling over 50,000 copies. Robeson became a top recording star, actor, singer, socialist and civil rights activist.

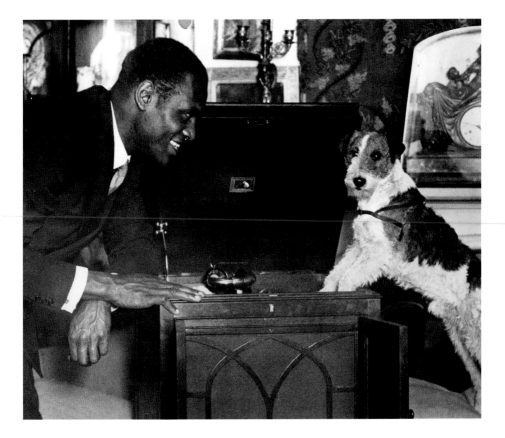

Keith Moon with a puppy, 1972

Keith Moon (1946–78), drummer with The Who, was the quintessential hard-living rock star with a heart of gold – a dangerous man to be around, especially if he was in charge of a vehicle. He famously drove a Rolls-Royce into his swimming pool, drove his hovercraft to the pub, and landed on Oliver Reed's lawn in his helicopter to introduce himself. Moon and Reed became close friends, their friendship oddly spurred by Moon's obsession with Dickens's Bill Sikes. Reed had starred as Sikes in the film *Oliver* (1968), a role which Moon's great hero Robert Newton played in David Lean's *Oliver Twist* (1948). Moon not only imitated Newton but looked like him, too, and the idea of having a dog that looked like Newton's must have been irresistible – not a bull terrier, perhaps, but a dog with a real 'bullseye' patch, recalling the name Dickens had given Sikes's dog. Not that Moon was the perfect owner. In Terry Fletcher's Keith Moon biography, *Dear Boy* (1998), the guitarist Jeff Beck recalled staying at Moon's home, Tara, in 1973: 'The dog situation was not good: I'd never seen such a mess in my life, the dog mess. He hadn't made the slightest attempt to clean it up. It wasn't like this is designer dog shit, it was like this guy hasn't any idea how to look after a dog.' Moon died in 1978, at the age of 32, from an accidental overdose of Hemineurin, a medication for combating alcoholism.

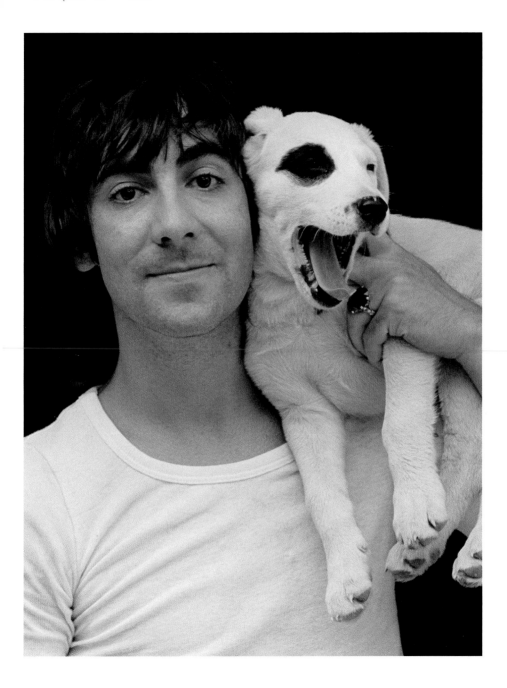

Marc Bolan and **Mickey Finn** with two Irish wolfhounds, 1974

Marc Bolan (1947–77) and Mickey Finn (1947–2003) are posing here for a T Rex publicity shot with a pair of Irish wolfhounds, oddly enough at almost exactly the time rival glam rock star David Bowie was being photographed with a Great Dane for his *Diamond Dogs* album (see p.117). The Bolan dogs are bigger, though T Rex were in decline at this point, after a brief – three-year – stint of stratospheric pop stardom. Bolan, following on from an early career of hippy singer-songwriting as Tyrannosaurus Rex, had stripped down his songs, put on the eye make-up and glitter, and seized the role of pop idol, which had lain vacant, in the UK at least, since the end of The Beatles. Bolan died young, aged 29, in a car crash, with both musical careers already essentially in his past, but his death ensured posthumous legendary status.

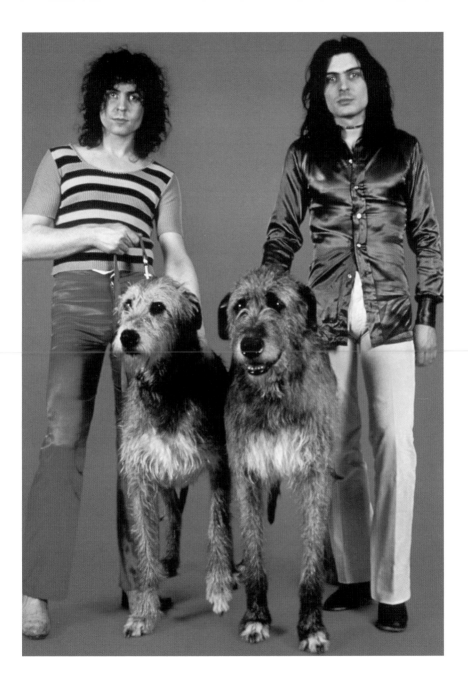

J.R. Ackerley with Queenie his Alsatian bitch, 1950

The novelist, writer and literary editor Joe Ackerley (1896–1967) immortalised Queenie in *My Dog Tulip*, which Christopher Isherwood called 'one of the greatest masterpieces of animal literature' and Rosamond Lehmann praised as the only dog book she knew 'to record human–animal love in terms of absolute equality between the protagonists'. Ackerley adored Queenie – a rescue dog whom he calls Tulip in the book – and she adored him. 'I was just under fifty when this animal came into my hands, and the fifteen years she lived with me were the happiest of my life,' he wrote. He certainly put the dog first, apologising to guests such as E.M. Forster and Lucien Freud (who tried but failed to draw her) about Queenie's need to, as he put it, perform her 'operations'. To Ackerley she had the 'beauty of a Rouault portrait'. How he wished he had shared his life with an animal, Ackerley wrote to James Kirkup in 1963, 'when I was younger, instead of running about all the time after boys.'

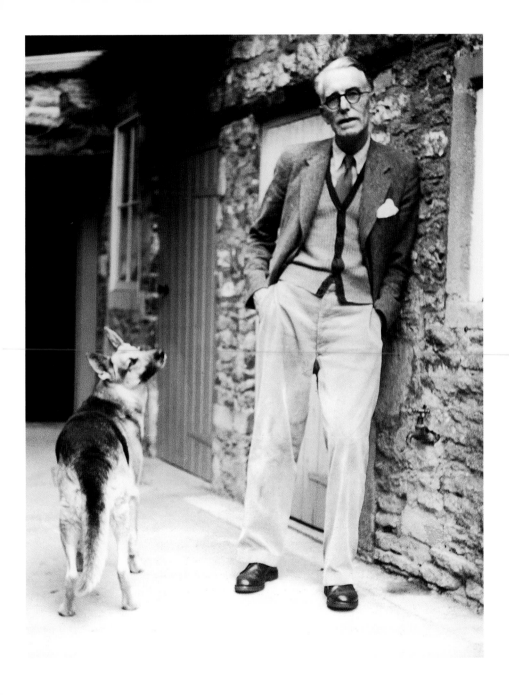

David Bowie with a Great Dane, 1974

For the cover of the *Diamond Dogs* album, Belgian artist Guy Pellaert depicted David Bowie (born 1947) sphinx-like, half-man, half-dog, basing the lower body on a Great Dane who modelled for him. The photographer Terry O'Neill decided to record the process and do a studio shoot of Bowie and the huge dog. As he started taking pictures, the dog leapt towards him: 'It was an awesome sight because the dog was bloody massive. But David just sat there, cool as a cucumber. He didn't react to the dog at all. I guess he was posing immaculately. Most rock stars would jump a mile if that happened.' This memorable image was runner-up in Q magazine's list of '100 Greatest Rock'n'Roll Photographs' in 2002.

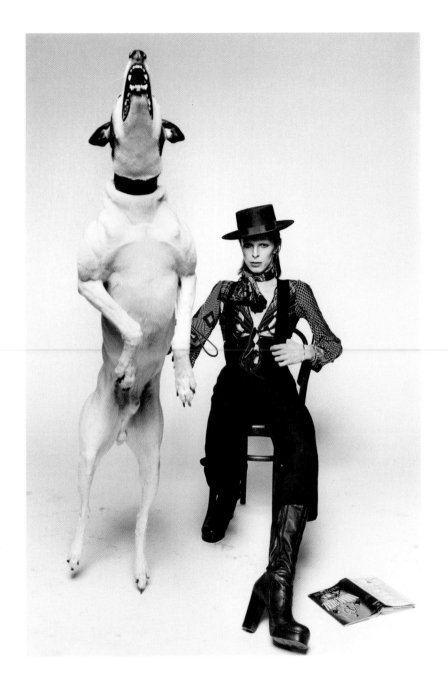

Gregory Peck with Slip and her puppies, 1949

Gregory Peck (1916–2003) was making the film *The Gunfighter* when his white German shepherd Slip gave birth to thirteen puppies at his home in Pacific Palisades. With too many puppies and not enough milk, Peck was photographed in his role as co-mother to the litter, bottle-feeding a pup. He kept one of them, Perry, who became a magnificent dog. Peck was at the time a huge postwar Hollywood heart-throb, having starred as the mad, bad and sexy Lewt McCanles in *Duel in the Sun* (1946). However, the studio were keen to promote his serious and intelligent nature – partly through publicity shots of him with his dogs – as he went on to star as the noble Captain Hornblower in *Captain Horatio Hornblower, RN* (1951). The fact that his fondest memories of childhood were of his grandmother, who took him to the movies every week, and of his dog, with whom he was inseparable, was a plus. Nor was it hype: after his close friend Ava Gardner's death, Peck took in her housekeeper and adopted her corgi, Morgan.

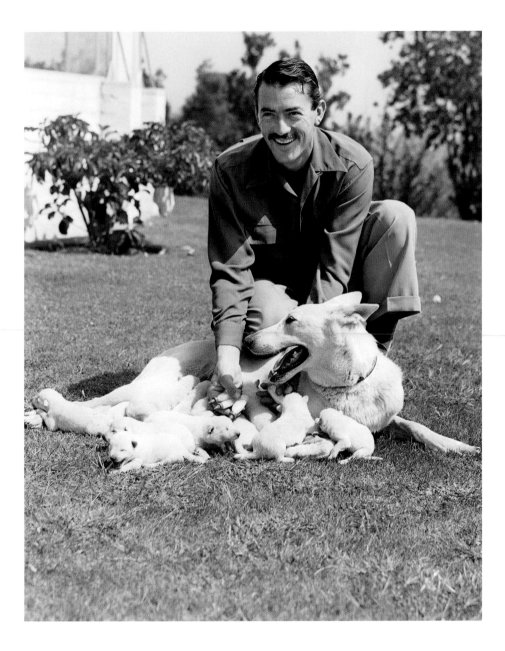

John Noakes and Shep, the Border collie, 1971

Dogs were a central element of the BBC TV children's show *Blue Peter*, right from its inception, with each presenter having their 'own pet', whose care they would explain to viewers. John Noakes (born 1934), the show's madcap (and latterly cultish) presenter, is pictured here holding his new puppy in the *Blue Peter* garden at BBC Television Centre. Patch, Noakes's dog since 1966, had died a few weeks previously, and there was nationwide excitement as to who his new dog was to be. A Border collie pup, an egalitarian working dog familiar to children in both rural and urban areas of the country, was chosen, and called Shep. He and Noakes were a great duo, the training was entertaining and instructive and the admonishment 'Get down, Shep' became a catchphrase (and the title of a song by comedy group The Barron Nights). When Noakes left the TV show in 1978, the BBC, which owned Shep, allowed him to go with his master and he appeared in five series of *Go with Noakes*. Shep died, aged 16, in 1987.

Baron von Richthofen and his Great Dane, *Moritz,* 1914

The Red Baron – the flying ace and fighter pilot Baron Manfred von Richthofen (1892–1918) – was one of the legendary figures of early air combat. He began the war as a cavalry officer in the Prussian Army, but the invention of the machine gun had changed the face of combat and he turned instead to the air. After only 24 hours of training, the Baron made his first solo flight, and he went on to shoot down eighty Allied planes in combat before being killed in the skies over Vaux-sur-Somme in 1918. The Baron bought Moritz, a brindled Great Dane (in fact, a German breed) from a farmer in Flanders. He shared his master's bed, was in the plane for some of the Baron's most important 'dog fights', and appears in almost all of his wartime photographs.

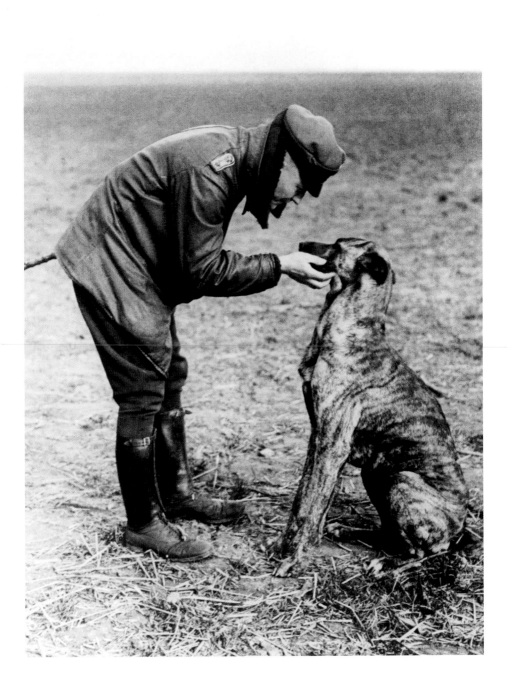

President Roosevelt and **Fala** the Scottish terrier, c.1942

Franklin D. Roosevelt (1882–1945) was into his third term as president when, in 1940, his cousin Margaret Suckley handed him a seven-month-old black bundle of energy. Roosevelt had wanted a dog for years, but his wife Eleanor felt that the White House was no place for a puppy. The terrier, however, touched a nerve in FDR and he and Fala, as he named her, became inseparable, the dog sleeping by or on the bed, accompanying the president everywhere and lapping up every photo opportunity. Dorothy Parker described a Scottish terrier as one 'burdened with affairs of international importance, and who cannot be annoyed with merely local matters'. So Fala was the right dog for Roosevelt, himself on the verge of committing the US to the Allied side after Pearl Harbor in 1941. In fact, so concerned about the future was his owner that Fala's horoscope was drawn up by Lester Belt, a barber and canine astrologer from California. After FDR died in 1945, Fala lived with Eleanor Roosevelt and continued to keep an eye open for his master's return, and after he died in 1952 he was buried near Roosevelt in Hyde Park, New York. There is a statue of Fala at the FDR Memorial in Washington DC.

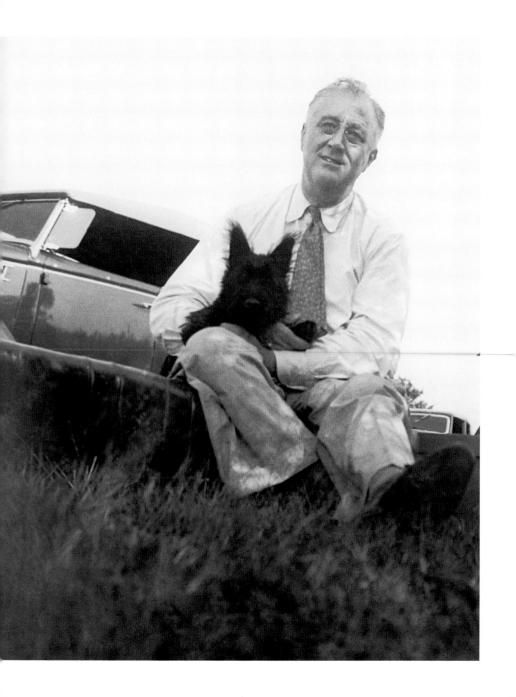

Peter Sellers and his Maltese terrier, Chussy, c.1955

At the time of this photo, Peter Sellers (1925–80) was appearing in the radio programme *The Goon Show* with Spike Milligan, Michael Bentine and Harry Secombe, playing such characters as Major Bloodnok, Bluebottle and Henry Crun. Film stardom lay in the future. Sellers had an enormously close relationship with his mother, Peg, and after her death he would visit celebrity medium Doris Stokes to get in touch with her; but he told Spike Milligan that he most often got through to the late Chussy, who informed Sellers that he was very happy on the other side. Perhaps this is not so surprising: Sellers was an indifferent animal lover, and in a row with his third wife he strangled her parrot and chucked one of her puppies into a swimming pool. The pup, at least, was fished out.

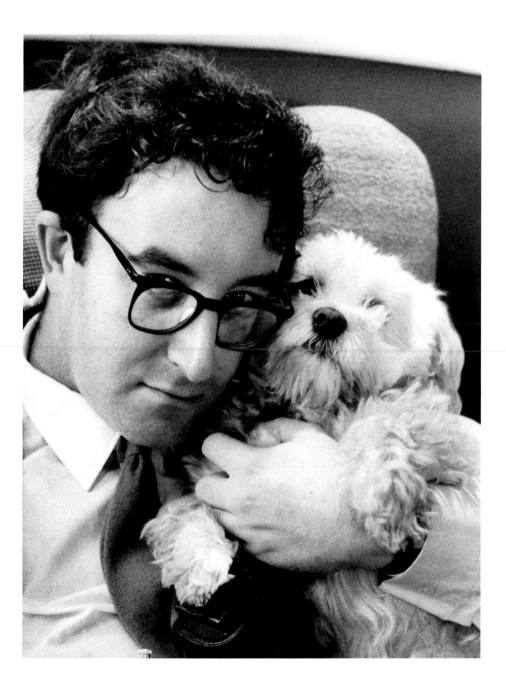

Josip Broz (Marshal Tito) with his German shepherd, Tiger, 1944

This historic photo shows Josip Broz (1892–1980), later known as Marshal Tito, enjoying a dip with his dog Tiger near the Yugoslav guerrilla army's secret wartime headquarters in 1944. Tiger, it is said, was as close to the legendary marshal as anyone, and saved the future president's life during the Battle of Sutjeska. Somewhat bizarrely, this episode was the basis of a movie, *The Fifth Offensive* (1972), in which Richard Burton played Tito but notably failed to bond with his canine co-star.

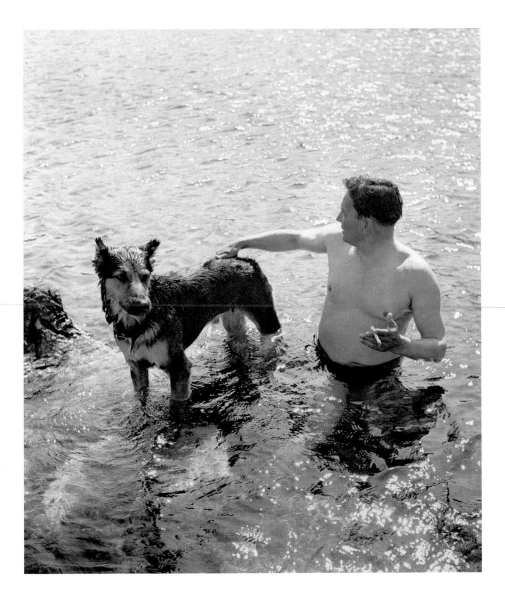

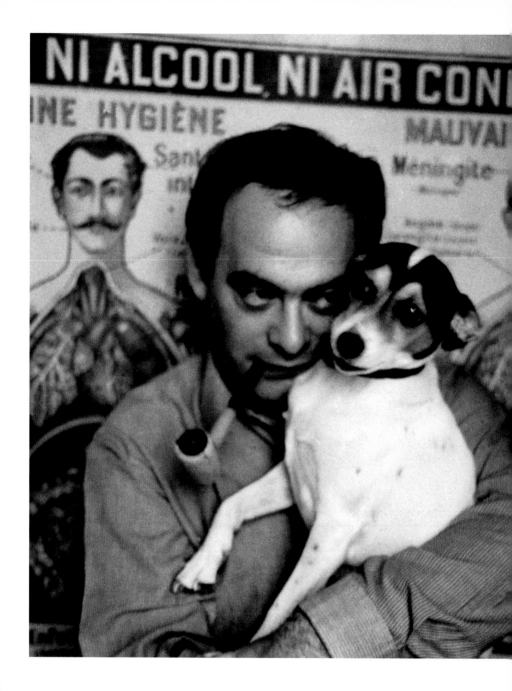

Roland Topor and his Jack Russell terrier, c.1965

Posing with his little Jack Russell terrier, this is the French artist Roland Topor (1938–97) – one of the twentieth century's great polymaths. An iconocolast and absurdist, he played and excelled in almost every medium: he was a Dadaist artist, a prolific novelist, a playwright, an actor, a puppeteer, a songwriter, a graphic artist and cartoonist. Among his better-known projects, he devised the visuals for the cult sci-fi movie, *The Fantastic Planet*, wrote the original novel for Polanski's *The Tenant*, and acted in Werner Herzog's remake of *Nosferatu*. He lived life to the limits, to his own unique brief: 'Everybody should be freer than they are,' he wrote. 'Too much fear is control. People are manipulated. They are given desires like a car, house, dog, or religion, and it's terrible that many are doing things that they are told.'

Rudolph Valentino with his German shepherd, **Prince**, c.1923

Rudolph Valentino (1895–1926) was born in southern Italy, the son of a vet, whose love of animals he inherited. When this photo was taken, at Falcon's Lair, his Beverly Hills mansion, the dancer and actor was established as Hollywood's first great male sex symbol. His (bisexual) love affairs and passions were numerous, but he told a journalist that 'my chief interests away from the studio are my dogs and my horses. I have two prize-winning Great Danes, and I like to ride every day of the week.' Alongside a pet lioness, Zeta, Valentino kept fourteen dogs at Falcon's Lair, including this German shepherd and a Doberman called Kuba, the gift of his friend and alleged lover Jacques Hebertot ('a man's dog for a man's man!' as Hebertot put it). Valentino's passion for dogs was shared by his second wife, and greatest love, the designer Natacha Rambova, who bought a trio of Pekingese in Paris, but it was not enough to keep the two together. Valentino desperately wanted children, as well as animals, in his life, while Rambova was interested only in her career, and like Valentino was predominantly gay. When they divorced, a few months before his death from a perforated ulcer in 1926, Valentino recognised the irony of his situation: 'I have often thought to myself, "The great lover, loved by all but his loves".'

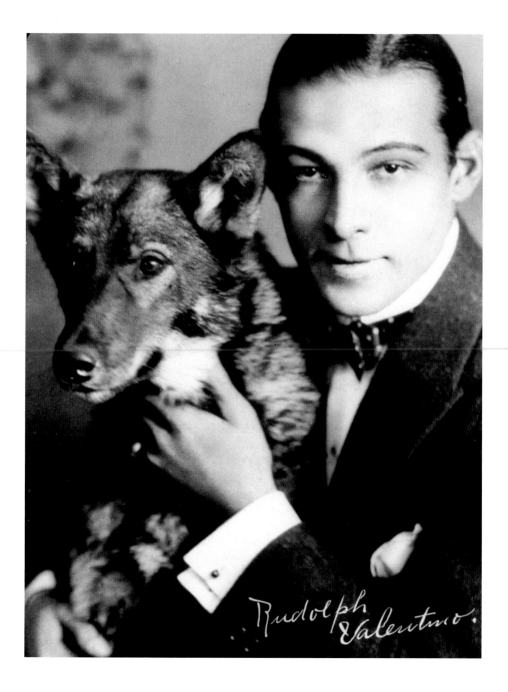
Rudolph Valentino.

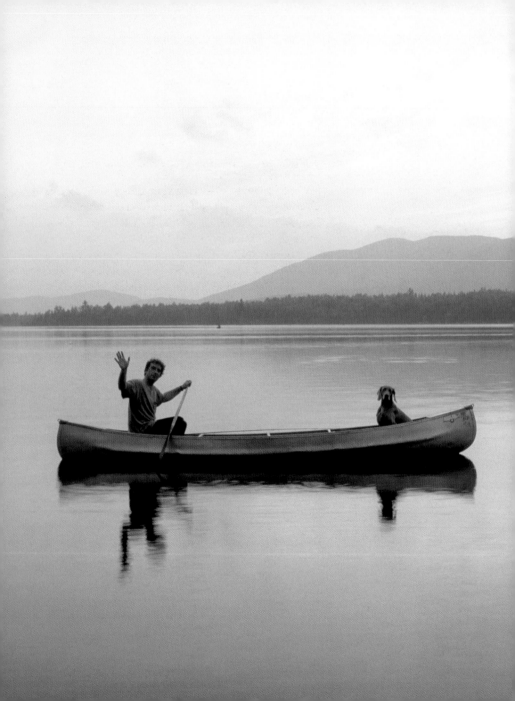

William Wegman and Fay Wray, the Weimaraner, 1988

No photographer is associated so closely with dogs as William Wegman (born 1943), whose famous Weimaraners have become artworks and celebrities. Ever since Wegman answered an advertisement for puppies in a Los Angeles newspaper in 1970, and chose the only male of the litter, he has worked with these enigmatic retrievers with their pewter coats and golden-hazel eyes. At first he took simple photographs of his pup, Man Ray (1970–82), but before long 'posing became second nature' to the dog and he was wrapped in tinsel for *Airedale* or sprinkled with flour for *Dusted*. He became an international art celebrity as well as boon companion, always up for a game of dog baseball after a hard day in the studio. The artist said he felt they were just beginning to 'do something' when Ray died. Two years later the beautiful Weimaraner bitch Fay Wray (1984–95) entered Wegman's life: 'Fay enticed me to begin photographing her although I had been reluctant since Man Ray's death. Her liquid beauty came pouring out of these first pictures.' Wegman placed her on a stool so they were at eye level and tried draping and dressing her: 'Dressing animals usually appears ridiculous. But, there was nothing clownish or demeaning about Fay, a little eerie maybe, but not silly.' Anxious to ensure that her line continued, he bred Fay and in 1989 she had nine puppies. One of these was Battina, or 'Batty', a natural comedian with a sweet nature and nonchalant attitude who, taught by her mother, became an excellent model and subject, posing with Fay in *Ladies Day* (1994) and on her own in numerous works.

P.G. Wodehouse with Jed, the dachshund, and Debbie, the boxer, 1960

P.G. 'Plum' Wodehouse (1881–1975), the creator of Jeeves, Bertie Wooster and Lord Emsworth, scattered dogs (and pigs) liberally about his fiction, and if you dip into his letters you will find he writes about almost nothing else. Dogs, indeed, were partly the cause of his wartime internment and the subsequent 'treachery' allegations that clung to him throughout the rest of his life. To avoid paying both US and UK tax, the Wodehouses had been living in the French resort of Le Touquet, along with a number of British ex-pats. While most of them returned to Britain at the outset of war, the Wodehouses hesitated, not wanting to put their Peke, Wonder, into unneccessary quarantine. They waited too long, and in May 1940 were overtaken by the Nazis' rapid advance. The writer was interned, but later released by the Germans, to live in Paris, after agreeing to record two radio broadcasts to his fans in then-neutral America.

In his fiction, perhaps the most memorable Wodehouse dog was Bartholomew, Stiffy Byng's censorious little dog, whom he modelled on Angus, an Aberdeen terrier, 'who would look at him like a Presbyterian preacher about to harangue his congregation'. But there were many, many other candidates. Wodehouse and his wife Ethel had a shared love of animals and their house was a refuge for stray dogs, cats, and even parrots. Jed the dachshund arrived at their home in America in 1958, imported from England, and was famously indifferent to housetraining, preferring carpets to any other kind of litter. He was clearly indulged, as was Debbie the boxer; in a letter of 1961, Plum bemoaned the fact that the new Irish cook stoutly refused to allow Debbie to sleep on her bed. However, the Wodehouse all-time favourites were their Pekingese: Wonder, Miss Winks, Squeaky, Mrs Miffen, Loopy and Boo among them. 'As life goes on,' asked the author, 'don't you find that all you need is about two real friends, a regular supply of books, and a Peke?'

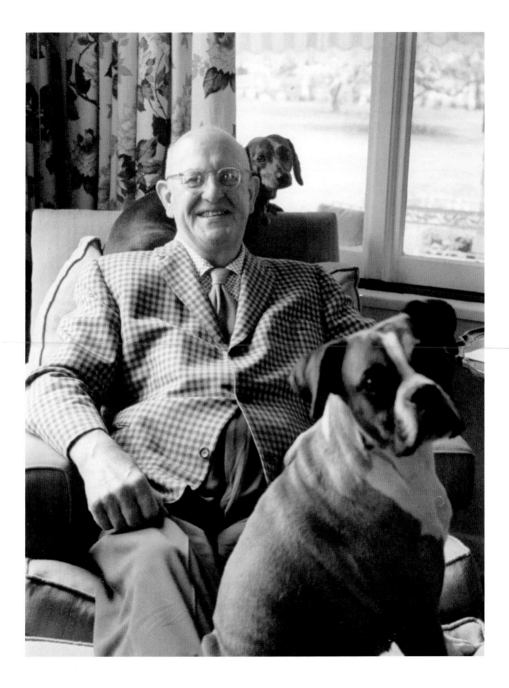

Yves Saint-Laurent and **Moujik III**, his French bulldog, 1994

The great French couturier and designer Yves Saint-Laurent (born 1936) has always kept dogs, with a line stretching from Bobinette, his childhood pet, through Zou Zou, a stray mongrel, to Hazel, a beloved chihuahua. However, in recent years, the designer – a devotee of Marcel Proust and Belle Époque Paris – has kept French bulldogs. The first of these was Moujik, a grouchy and snappy dog, doted upon by his owner, who irritated the models at the Maison Marceau by demanding attention and dribbling on their clothes. But Moujik began a dynasty and bulldogs became part of the Saint-Laurent legend, immortalised by Andy Warhol's series of portraits. At the *Vogue* interview at which this picture was taken, writer Lesley White was bitten by the dog – Moujik III – who, when put outside, banged against the door repeatedly in his attempt to be part of the action.

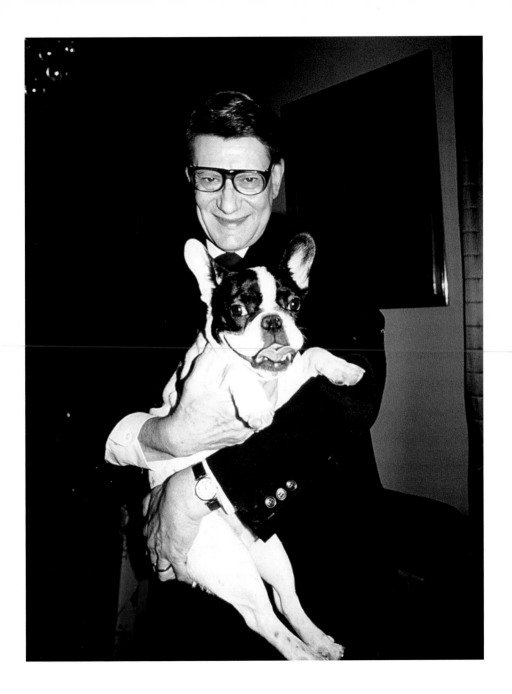

Prince Felix Yussupov and a pug, 1965

Cecil Beaton took this picture of Prince Felix Yussupov (1887–1969) at the Yussupovs' apartment in Paris in 1965. On the front door a sign read 'chien mechant', but the prince's pug was too old to be even remotely threatening. Yussupov himself was 78 but belonged to an even older and more distant world. A bisexual transvestite, and once one of the richest nobles in Russia, he was involved in the assassination of Rasputin in 1917, earning a rather fortunate exile from Russia with his wife, Princess Irina. In Paris he became a friend of the Windsors and, like them, a pug fancier. But he was passionate about little bull-breed dogs in general, and in his memoirs, *Last Splendour*, singled out his French bulldog Gugusse – who for eighteen years slept in a cushion beside his bed – and his bulldog Punch, acquired when he was at Oxford, whom he slipped through British Customs dressed as a baby, carried by an old cocotte. 'Not a soul suspected the fraud', he wrote with great amusement.

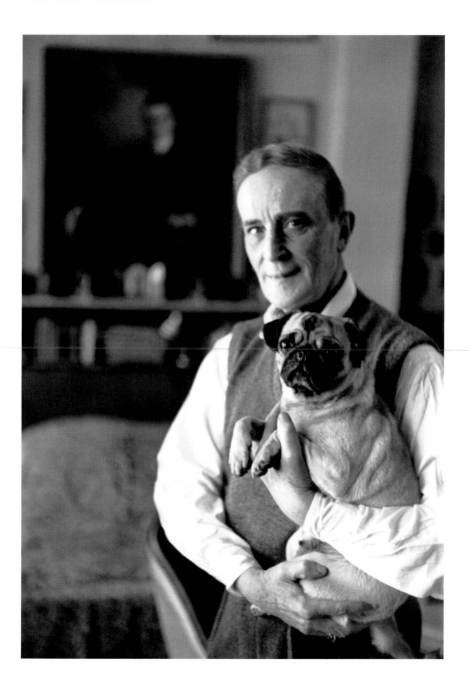

Franco Zeffirelli with his Weimaraner, 1981

In his autobiography, the director Franco Zeffirelli (born 1923) described his dogs in the same breath as his closest friends – as 'loyal creatures' – and extols the most recent addition to his home, Bambina, with whom it was 'love at first sight'. In 1968, after directing Richard Burton and Elizabeth Taylor in *The Taming of the Shrew*, Zeffirelli had a terrible car accident and spent months in hospital. His German shepherd dog Gosto missed him dreadfully and Zeffirelli had his clothes sent back home so Gosto could smell them and be reassured that his master was still alive. He went on to make *Brother Sun Sister Moon*, the story of his name saint, St Francis of Assisi, whose outlook of 'finding only in animals perfect love and giving' the director said he shared. Zeffirelli campaigns for animal welfare in Italy, and when he was making the film *Callas Forever* in Romania, in 2003, he rescued a number of stray dogs and gave them a home on his estate outside Florence with his Jack Russells, Blanche and Martino. In this photo he is relaxing at his villa in Positano, with a favourite Weimaraner.

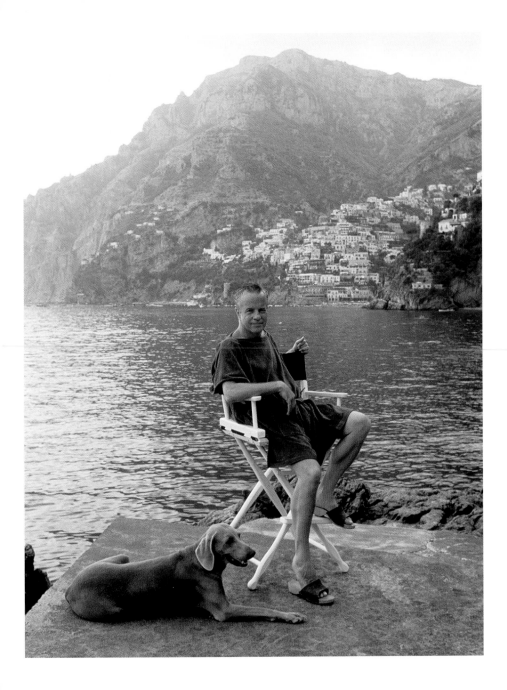

Roy Harris training with his dog, 1958

Heavyweight boxer Roy Harris (born 1933) is training here with his dog, near his home town of Cut'n'Shoot in Montgomery County, Texas, for his August 1958 fight with the heavyweight boxing world champion Floyd Patterson. A local hero, Harris appeared on the cover of *Sports Illustrated* holding a shotgun and flanked by his two hunting dogs, and cut a record, ' Cut'n'Shoot, Texas', before his fight with Patterson, which he lost in the thirteenth round. Harris recalled that everyone in his town, boys and girls alike, boxed, and he and his brother traded wild ducks they had shot for a first pair of gloves, which they shared. He retired from the ring in 1961, trained as a lawyer, and became a prominent citizen of Cut'n'Shoot.

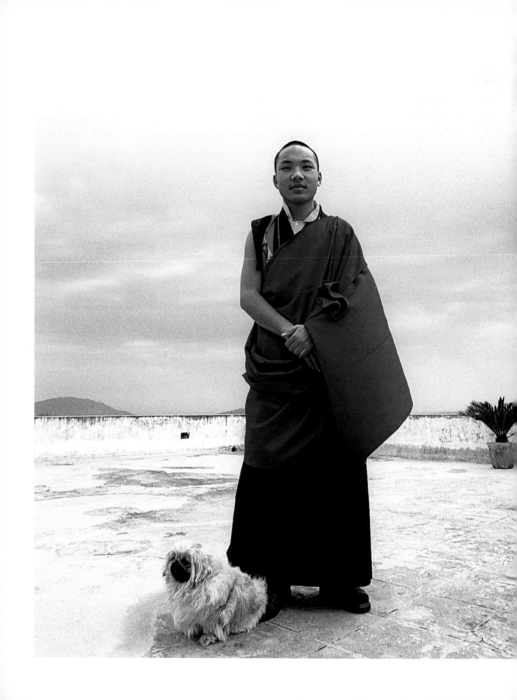

The Karmapa with his Pekingese, **Dekyl**, 2001

His Holiness Ogyen Trinley Dorje (born 1985), 17th Karmapa, stands on the roof of the Gyuto monastery in Dharamsala, India with his Pekingese, Dekyl. This dog has for over a thousand years symbolised the lion, sacred steed of the Buddha in Chinese Buddhism, and according to legend the souls of some lamas progress into the bodies of lhasa apsos, the sacred dog of Tibet, before manifesting as the next lama. The Karmapa, head of the powerful Kagyu sect, is second only to the Dalai Lama as spiritual leader of Tibetan Buddhism, and is considered preserver of an unbroken line of teachings of the Buddha. The present Karmapa was born into a family of nomadic yak- and goat-herders in eastern Tibet, before being acclaimed in 1992. The Chinese groomed him as their successor to the exiled Dalai Lama, but he escaped on December 28, 1999, travelling 900 miles in three days over the Himalayas, and since then has lived in political asylum in India.

Frank Sinatra with a West Highland white, 1958

It is not known who this little dog is on stage with Frank Sinatra (1915–98). Perhaps it was just for the photo opportunity; nevertheless, 'Old Blue Eyes' was quite a dog man, keeping a cocker spaniel called Miss Wiggles and a Labrador called Leroy Brown, among others. And among his wives and girlfriends were notable dog women, including Ava Gardner, Zsa Zsa Gabor, Elizabeth Taylor, Lauren Bacall, Jackie Kennedy and Mia Farrow. Dating Marilyn Monroe, he gave her a white poodle which she called 'Maf', an allusion to Sinatra's alleged Mafia connections. Sinatra's last wife, Barbara Marx, kept many rescued dogs at their home and recalled that one little King Charles spaniel would bark an accompaniment whenever he sang.

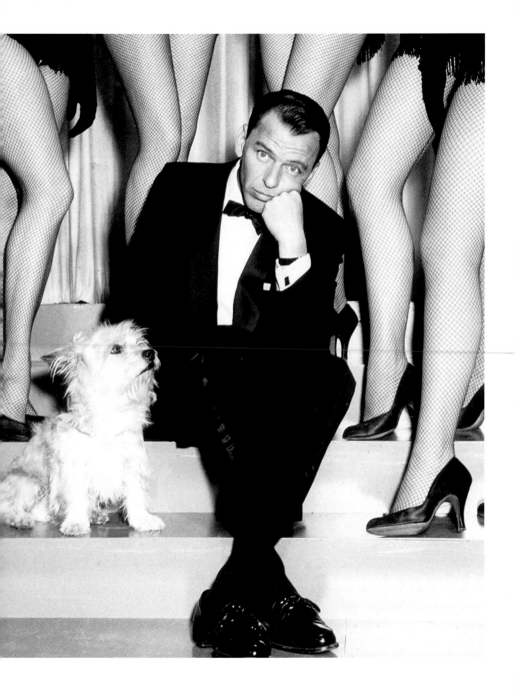

Tom Wolfe and his Jack Russell, **Strawberry**, 1988

Dandy, literary journalist and author Tom Wolfe (born 1931) is perfectly complemented by a Jack Russell terrier, in this shot taken at his home in Manhattan soon after the publication of *The Bonfire of the Vanities*. His choice of dog is deliberately Anglophile; Jack Russells were not only unusual in New York City, but also reminded everyone of the writer's English influences: 'I'm Addison and Steele, or the early Thackeray. Look at Dickens's *Sketches by Boz*,' he told *Vanity Fair* shortly before this photo was taken. An astute social satirist, Wolfe has often used dogs to describe a character or situation: in a piece for the *New York Herald Tribune*, for example, he wrote of the 'forward-tilted gait that East Side dowagers get after 20 years of walking small dogs up and down Park Avenue'. And in *The Bonfire of the Vanities*, Park Avenue liberal Sherman McCoy has one of the most fashionable dogs of the day, a dachshund, comically named Marshall, whom he drags out in the pouring rain as an alibi when he wants to phone his mistress.

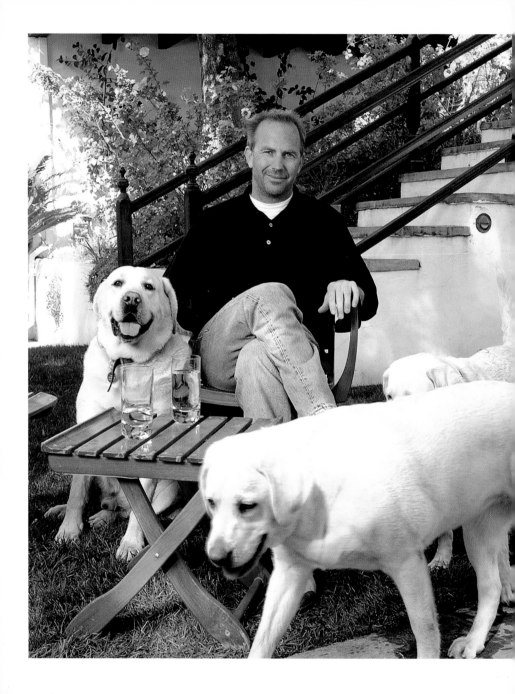

Kevin Costner at home with **Rosalita**, **Wyatt** and **Daisy**, his golden Labradors, 2002

Actor and director Kevin Costner (born 1955) is well-known for his love of dogs, a passion that has been emerging in his movies. As director of *Dances with Wolves*, he memorably gave weight to Lieutenant John Dunbar's relationship with the wolf, while in *Open Range* (2004) the death of his dog sparks the drama of the story. In real life, Costner has a dynasty of golden Labradors. The mother of them all was Rosalita, who played the character Rocky alongside Costner in the action film *Revenge* (1989). She is sitting with Costner in this photograph, looking on at her pup Wyatt, named after the legendary lawman Costner played in *Wyatt Earp*. Costner had to call on the services of Hollywood dog trainer Inger Martens to discourage Wyatt from leaping on the family in the swimming pool, and Martens was again in demand when Daisy, the third golden Labrador, arrived in 2000, to cure her shoe- and furniture-chewing habits. Martens said the star was 'wonderful' with dogs, and with his ranch in Aspen, Colorado, this trio must have a good Labrador lifestyle.

Philip Pullman with his lurcher, **Daisy**, 1999

Author Philip Pullman (born 1946) stands outside the shed in which he wrote his extraordinary fantasy trilogy, *His Dark Materials*, and is greeted by his lurcher Daisy. 'We got her from a rescue place. She was a lurcher of unknown parentage, and my wife named her. She was a family dog, and very gentle and kindly.' Pullman's imaginary worlds are full of animals – warrior bears in body armour, daemons, the external souls of people in heroine Lyra's universe, who can take the form of anything from an ermine to a snow leopard. He has little truck, however, with many dog stories: 'very difficult to do without becoming sentimental – see Kipling's grotesque *Thy Servant A Dog* for the worst example in the world. Animals often embody one particular human characteristic (the faithfulness, or whatever) and only that, but do it to an intense degree. That's why we've always used them in heraldry, for example, and why my daemons have animal forms.' As a child, Pullman's family had two dogs, a corgi called Honey and a black Labrador called Bess, 'who was big and happy and daft'. After Daisy died in 2000, he and his wife Judith chose sibling pugs called Hogarth (after the eighteenth-century artist William Hogarth, who famously painted his pug Trump in a self-portrait) and Nellie. 'They are very different from Daisy, but then they're different from each other, despite being brother and sister from the same litter. He is completely laid-back, dozy, agreeable; she is nervy, skittish, hyperactive. I like pugs for their ugly beauty and charm.'

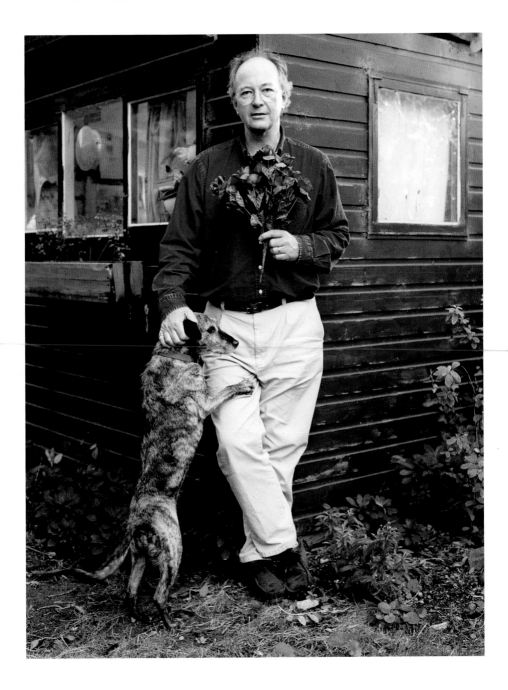

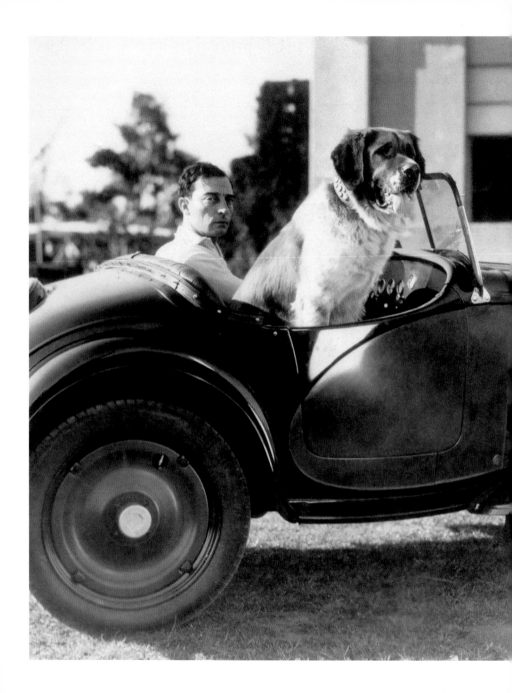

Buster Keaton with **Elmer I**, his St Bernard, c.1935

The silent movie star Buster Keaton (1895–1966) kept a number of large dogs, three of which were called Elmer (Elmer I, II and III). But there was also Barry, another St Bernard; Captain, a Belgian sheepdog; and Trotsky, an Irish wolfhound. His dogs were genuine companions rather than the large dogs so many male screen stars of the time kept as status symbols – and his bungalow on the MGM lot in the 1930s was called 'Keaton's Kennel'. This photograph has a sad aspect as, in 1936, during the break-up of Keaton's second marriage, to Mae Scriven, she behaved with particular malevolence and sold Elmer without telling him. He hired a private detective to find the dog, but failed.

Kevin Spacey and **Legacy**, 1991

In 1999 Oscar-winning actor Kevin Spacey (born 1959) told the *Los Angeles Magazine* that, although he already had two dogs, the black Labrador-cross Legacy and a small terrier called Mini, he'd like to have more: 'I want to walk into my apartment in New York someday and just be buried by dogs, have fourteen dogs jump all over me.' He actually acquired Mini in London, when he was appearing in Eugene O'Neill's *The Iceman Cometh* in 1998, and missed Legacy so much that he went to Battersea Dogs' Home to adopt a dog. Nevertheless, he'd still call his home in Greenwich Village and 'speak' to Legacy on the phone; the dog would dance around in excitement and lick the receiver.

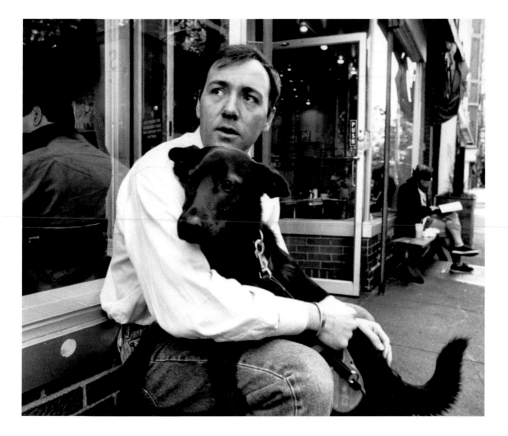

PICTURE CREDITS

All photos are copyright of the following picture libraries and photographers, and reprinted by permission:

Associated Press/Wide World Photos: Inside front cover (Mohammed Ali); p.15 (Elvis Presley) *Gene Herrick*.

Camera Press, London: p.103 (Alexander McQueen) *Derrick Santini*; p.113 (Marc Bolan) *Heilemann*.

Corbis: p.4 (George Custer); p.8 (Humphrey Bogart); p.12 (Paul Newman); p.16 (Gunnar Kaassen); p.26 (Neil Young); p.35 (Oscar Wisting); p.44 (Coalminer); p.48 (US sailors); p.52 (Sylvester Stallone); p.54 (America); p.68 (Richard Byrd); p.76 (DJ Muggs); p.78 (Kirk Douglas); p.88 (Bob Hope); p.92 (Clark Gable); p.94 (Ernest Hemingway); p.110 (Keith Moon); p.118 (Gregory Peck); p.122 (Baron von Richtofen); p.124 (FD Roosevelt); p.128 (Tito); p.142 (Franco Zefirelli); p.157 (Buster Keaton); p.150 (Tom Wolfe). *George Lange/Corbis Outline:* p.134 (William Wegman).

Karen Davies: p.146 (The Kamapa).

Marion Ettlinger: p.105 (James Ellroy).

Getty-Images (including Hulton Archive): p.10 (England World Cup Squad); p.32 (Harold Lloyd); p.41 (Will Smith); p.42 (David Duchovny); p.56 (Fatty Arbuckle); p.62 (Major Buckley); p.84 (Ian Fleming); p.86 (Errol Flynn); p.90 (Sigmund Freud); p.100 (Mick the Miller); p.108 (Paul Robeson); p.120 (John Noakes); p.126 (Peter Sellers); p.136 (PG Wodehouse); p.144 (Roy Harris); p.153 (Kevin Costner); p.158 (Kevin Spacey).

Idols/Kazuaki Kiriya: p.72 (Robbie Williams).

Katz: p.20 (John Peel) *Eleanor Bentall;* p.154 (Philip Pullman) *Neil Wilder.*

James Kirkup: p.115 (J.R. Ackerley).

Annie Leibovitz/Contact/nbpictures: p.61 (Marky Mark Wahlberg).

Library of Congress Prints & Photographs Division: p.46 (Assinboin Hunter) *Edward S. Curtis.*

Magnum: p.6 (Alfred Hitchcock) *Philippe Halsman;* p.24 (Winston Churchill) *Philippe Halsman;* p.28 (Dirk Bogarde) *Eve Arnold;* p.38 (Picasso) *Marc Riboud;* p.59 (Mikhail Baryshnikov) *Eve Arnold;* p.70 (Truman Capote) *Robert Capa;* p.74 (James Dean) *Dennis Stock;* p.96 (John Huston) *Eve Arnold;* p.131 (Roland Topor) *Ferdinando Scianna;* p.140 (Prince Yussupov) *Henri Cartier-Bresson.*

Mirropix: p.98 (Paul McCartney).

MGM Pictures/Dog Annual [London 1951]: p. 51 (Lassie).

Derry Moore/Vogue/Condé Nast Publications Ltd: p.31 (Craigie Aitchison).

Terry O'Neill: p.117 (David Bowie).

Popperfoto: p.22 (US pilots); p.66 (Richard Burton); p.80 (Edward VII).

Rex Features: p.18 (JF Kennedy) *Sipa Press;* p.36 (David Hockney) *Tony Larkin;* p.64 (Edwin Brough) *Dobson Agency;* p.82 (Bill Clinton); p.132 (Rudolph Valentino) *Snap;* p.148 (Frank Sinatra); p.138 Yves Saint-Laurent; inside back cover (Clint Eastwood) *Snap.*

The Royal Archives: p.106 (Francis Clark).

SOURCES

I have made use of numerous (auto)biographies, reference works and interviews, in books and online, in researching this book. Invaluable sources have included:

Traphes Bryant with Frances Spatz Leighton, *Dog Days at the White House*, 1975.

Herbert Compton (ed), *The Twentieth Century Dog, Vols I and II*, 1904.

Jilly Cooper, *Animals in War*, 1983.

Stanley Dangerfield, *Your Poodle and Mine*, 1954.

Dictionary of National Biography, 2004.

Patricia Dale-Green, *Dog*, 1966.

Marjorie Garber, *Dog Love*, 1997.

Christopher Hawtree, *The Literary Companion to Dogs*, 1993.

Leighton, R, *The New Book of the Dog*, 1907.

Konrad Lorenz, *Man Meets Dog*, 1953.

K. MacDonough, *Reigning Cats and Dogs: A History of Pets at Court Since the Renaissance*, 1999.

B. Vesey-Fitzgerald, *The Book of the Dog*, 1948.